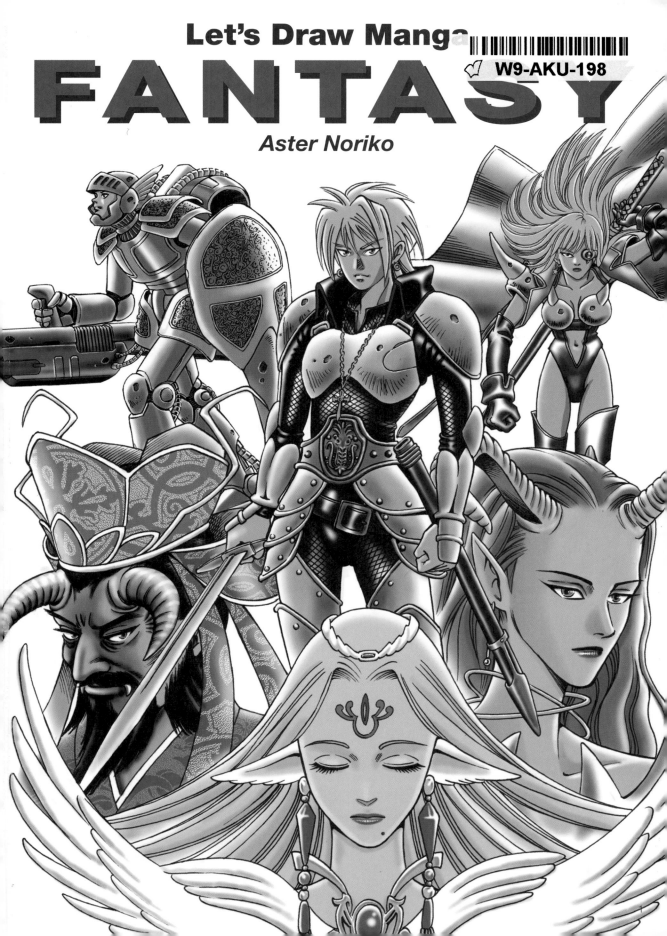

Let's Draw Manga
FANTASY

Aster Noriko

Composition .KEN SASAHARA
Illustration .ASTER NORIKO
Story boarding .ASTER NORIKO
MAKOTO
Artists .ASTER NORIKO
BUNTA 625
NORIKO NAKAJIMA
MAKOTO
Original Cover Art .ASTER NORIKO
Art Director .ASTER NORIKO
MAKOTO
Design .OSAMU KUNISHIGE

English Translation .NAOMI KOKUBO
English Language Edition LayoutJOHN OTT
Print Production Manager .FRED LUI
Copy Editor .STEPHANIE DONNELLY
Contributor .ISAAC "AKA-SAN" LEW
Cover Designer .ERIC ROSENBERGER
Publisher .HIKARU SASAHARA

LET'S DRAW MANGA
Fantasy

English Edition Published by
DIGITAL MANGA PUBLISHING
1487 W. 178th Street, Suite 300
Gardena, CA 90248
www.dmpbooks.com
tel: (310) 817-8010
fax: (310) 817-8018

ISBN: 1-56970-968-8
LCCN: 2005922392
First Edition October 2005
10 9 8 7 6 5 4 3 2 1

Printed in China

LET'S DRAW
MANGA
FANTASY

DMP
Digital Manga Publishing

Los Angeles

3

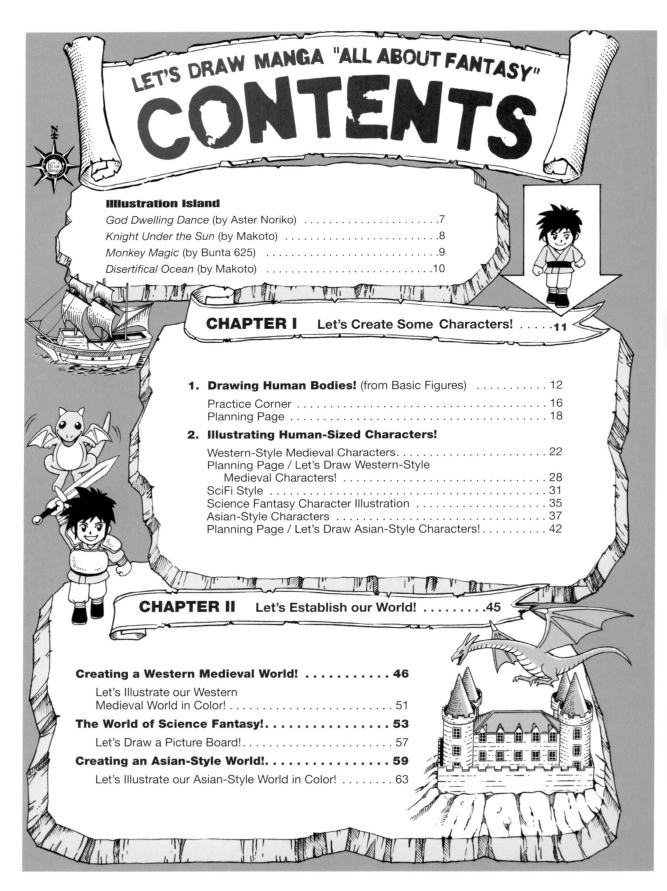

LET'S DRAW MANGA "ALL ABOUT FANTASY" CONTENTS

CHAPTER I Let's Create Some Characters!11

CHAPTER II Let's Establish our World!45

Level Passed !!

FOREWORD

These days, fantasy has established a firm foothold in worldwide media and pop culture.

By virtue of reading this volume, you probably have a pretty solid set of ideas about what comprises fantasy – but, to be pedantic, I'm referring to a genre of speculative fiction in which the physical world or laws of nature differ from our own, with no scientific explanation offered.

The origins of Western fantasy go back to Norse myth and heroic poetry such as the Anglo-Saxon text *Beowulf* and the Finnish *Kalevala*. In this book, however, by "fantasy" we refer to the modern genre represented by *The Lord of the Rings*. In other words, a medieval world populated by knights, fairies, and magic.

Although hardly the first fantasy novel written, *The Lord of the Rings* is, in a very real sense, the foundation for all modern fantasy. Although initially dismissed by critics, its obsessively-detailed world, based in Tolkien's love of linguistics, drew in audiences and spawned generations of imitators.

Its first Japanese translation was released in 1972; the majesty and imagination of its world received immediate attention and support from a passionate readership, and any number of new editions have been released in the years since.

Artists in a variety of fields also were influenced by it, and in referencing it they incorporated original elements into their work. After many years of turns and twists (and especially after the rise of computer games), fantasy became a mainstream part of Japanese youth culture. Although it might sound odd from a modern perspective, up until recently fantasy was a relatively niche framework for storytelling, derided as juvenile by literary critics and the mainstream audience alike. Although the reasons why are beyond the scope of this text, suffice that outside of children's books and some obsessive fan circles, fantasy has not always been in-vogue. Despite its rocky past, however, fantasy has witnessed a huge resurgence in recent years. In Japan, bookstores are now setting aside fantasy sections, opening the floodgate to popular works from around the world —and of course Japan is producing and publishing a good deal of its own fantasy. Through films, games, and manga, fantasy has become one of the central pillars of the entertainment industry, and now is acknowledged as a significant genre for all ages.

With this book it is our intention, as we teach the basics of manga illustration, to introduce the unique Japanese world of fantasy while keeping one foot in the familiar origins of the genre.

We hope it will be of aid to those who wish to translate their love of fantasy into Japanese manga!

For Big Mouth Factory— ASTER NORIKO

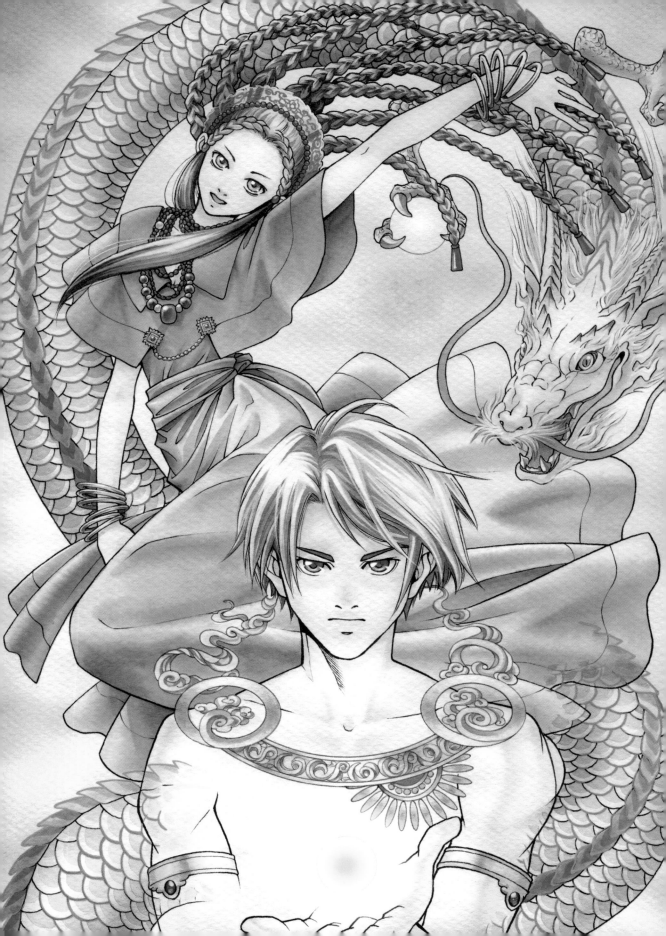

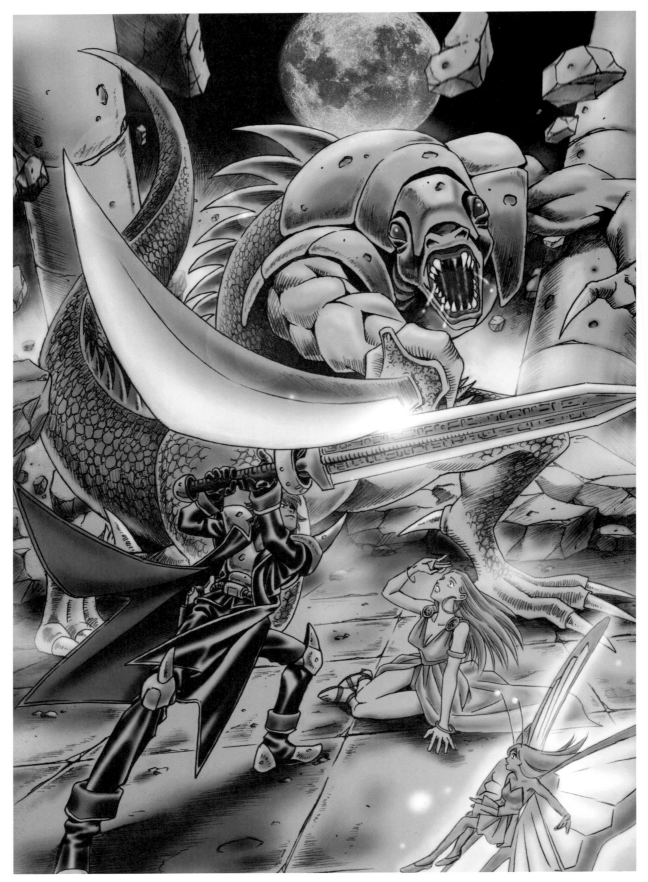

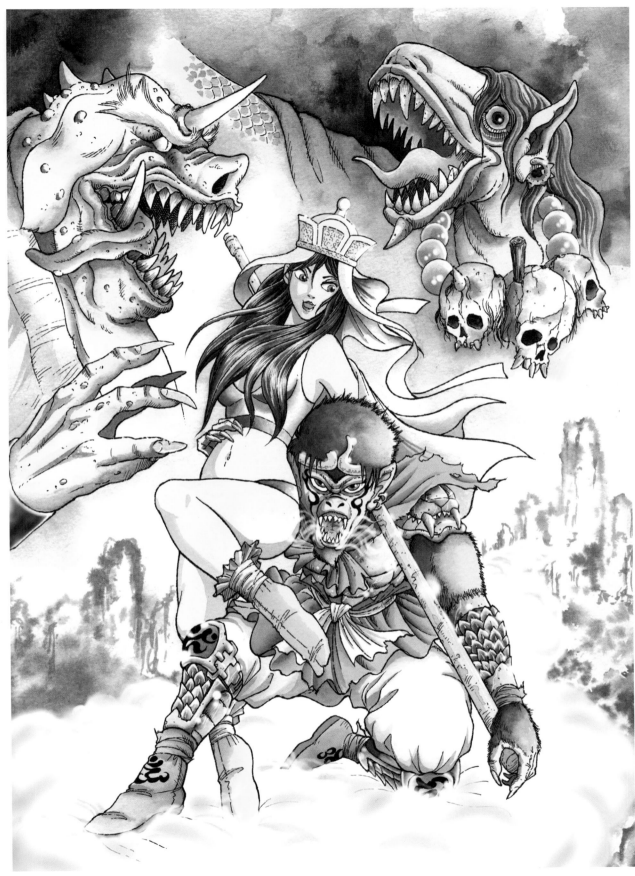

Let's Create Some Characters!

In manga, characters are central to the action! No matter how great the story is, if the characters are lifeless, there's no excitement. Here's how to create your own original and appealing characters!

Let's Create Some Characters!

Drawing Human Bodies!
(from Basic Figures)

We usually draw human figures without thinking too hard about it. However, a certain level of technique is necessary to draw well. When people begin to draw, they usually do so by copying. Although it certainly is a short cut, if we want to grow as artists we must learn a few basic methods. In this section, let's practice drawing human figures using some simple shapes.

STEP 1. Creating a Model

First, compose a human figure using circles, triangles, and rectangles. Try to capture each body part in a simplified form, as in the figure on the right.

You can divide a body to your taste, but pay special attention to its proportions. The midpoint (**M**)— half the body height— varies, based on the age of the character. The figure on the right represents a one-year-old infant, and that's why the midpoint falls on the pit of the stomach.

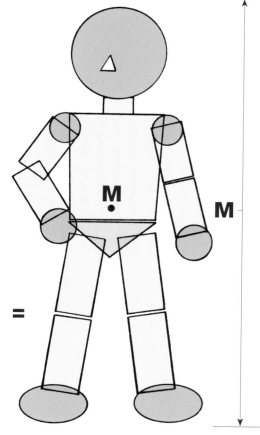

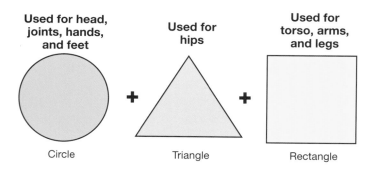

Used for head, joints, hands, and feet

Used for hips

Used for torso, arms, and legs

Circle **+** Triangle **+** Rectangle **=**

STEP 2 Sketching Over the Model

Add flesh to the figure and draw a face and clothes. Then stretch the lower limbs, altering the proportions to those of a ten-year-old.

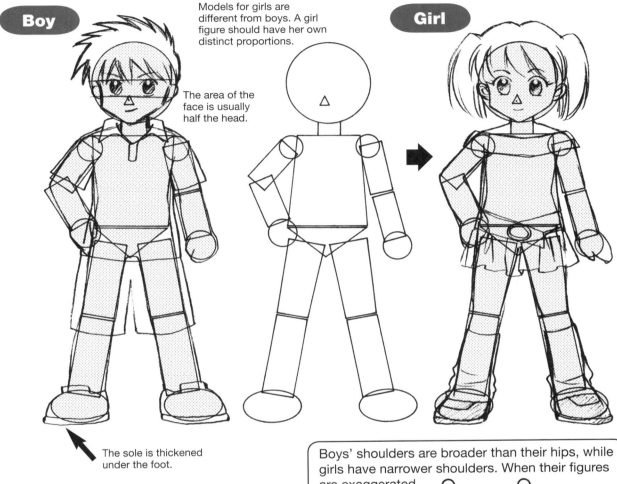

Boy

Girl

Models for girls are different from boys. A girl figure should have her own distinct proportions.

The area of the face is usually half the head.

The sole is thickened under the foot.

We're still working on rough sketches at this point, so you can draw however you imagine.

Boys' shoulders are broader than their hips, while girls have narrower shoulders. When their figures are exaggerated they should look like this: **Male** **Female**

STEP 3. Developing the Concept

As your story and your characters' personalities develop, so will their faces and clothing. Keep drawing, and allow your characters to grow!

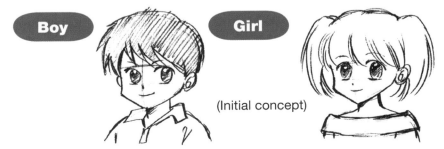

Boy

Girl

(Initial concept)

Boy

A hero. An elementary student who creates a U.M.A. (Unidentified Mysterious Animal) in science class. Raised in an ordinary household (parents, grandmother and older sister), and loves playing soccer and video games.

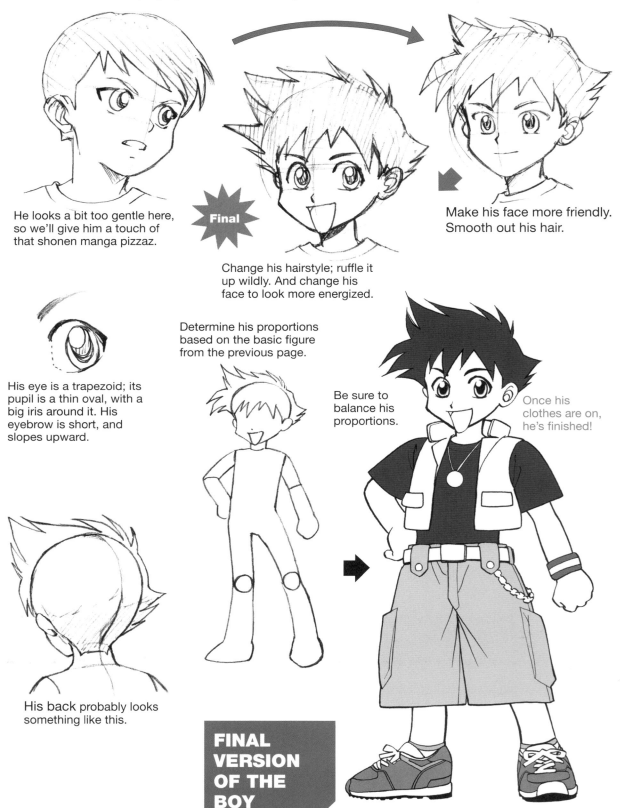

He looks a bit too gentle here, so we'll give him a touch of that shonen manga pizzaz.

Final

Change his hairstyle; ruffle it up wildly. And change his face to look more energized.

Make his face more friendly. Smooth out his hair.

His eye is a trapezoid; its pupil is a thin oval, with a big iris around it. His eyebrow is short, and slopes upward.

Determine his proportions based on the basic figure from the previous page.

Be sure to balance his proportions.

Once his clothes are on, he's finished!

His back probably looks something like this.

FINAL VERSION OF THE BOY

Girl Classmate of the hero. An only child, with a selfish streak. Gets into fights easily, but also cares about others. When she's with the hero, she can act like his older sister.

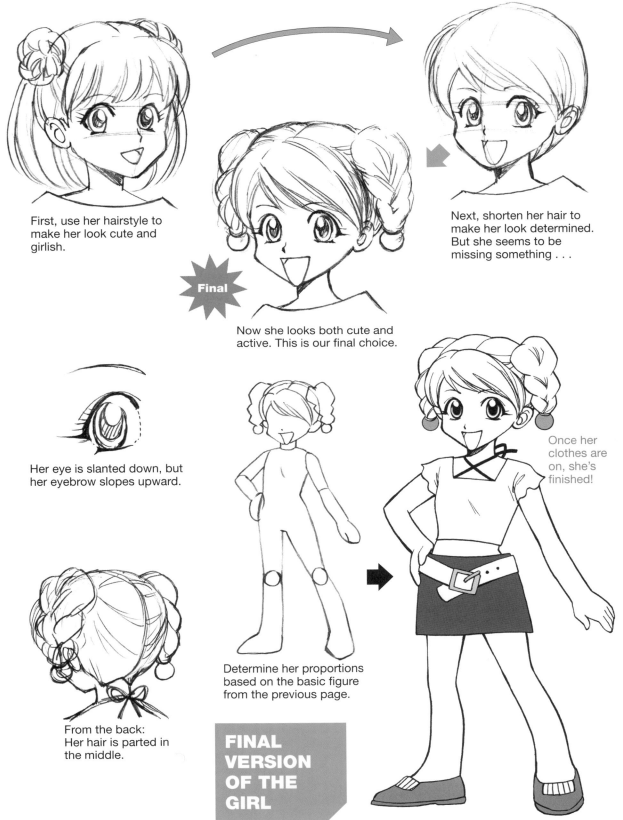

First, use her hairstyle to make her look cute and girlish.

Final

Now she looks both cute and active. This is our final choice.

Next, shorten her hair to make her look determined. But she seems to be missing something . . .

Her eye is slanted down, but her eyebrow slopes upward.

Determine her proportions based on the basic figure from the previous page.

Once her clothes are on, she's finished!

From the back: Her hair is parted in the middle.

FINAL VERSION OF THE GIRL

Let's Create Characters

Practice Corner

Let's Draw Pet Characters
(from Basic Figures)

You can create a small, mysterious creature that will serve as a guide to the world of fantasy. This creature will help the hero, and maybe even frustrate him, too! What role it ends up playing in the story is up to the creator.

STEP 1. Creating a Rough Concept

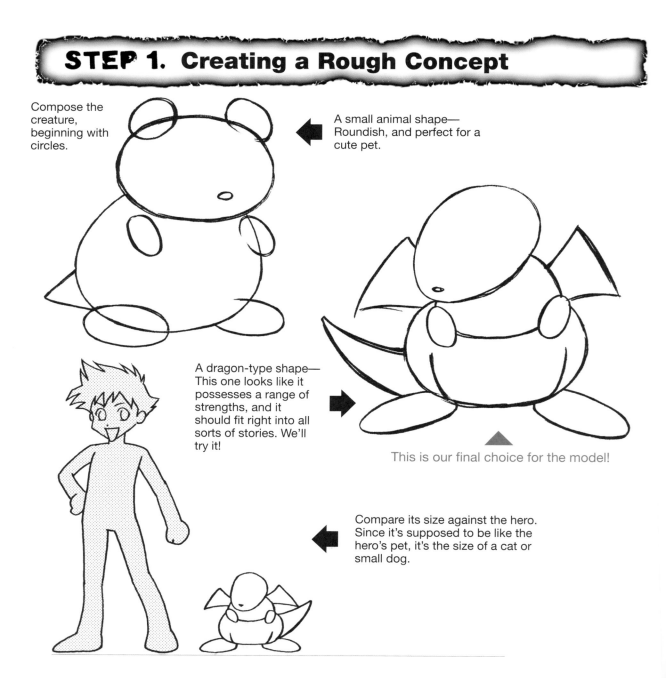

Compose the creature, beginning with circles.

A small animal shape— Roundish, and perfect for a cute pet.

A dragon-type shape— This one looks like it possesses a range of strengths, and it should fit right into all sorts of stories. We'll try it!

This is our final choice for the model!

Compare its size against the hero. Since it's supposed to be like the hero's pet, it's the size of a cat or small dog.

STEP 2. Developing the Concept

Rough story outline:

In the year 20xx, our hero winds up creating a strange creature at school. Since it is friendly, it becomes his pet – but it appears to possess an incredible power.

←Ears? Horns?

←Lovely eyes

←Use another color for the belly.

←Thick and short tail.

←Now, the body is more or less finished.

First rough draft

Its eye is monochromatic and round, with a big iris.

Think of what to put on its head.

1

2

3

1 FIRST, RENDER A SIMPLE FIGURE.

There are three nails on his hand.

3 No. 3 seems the most balanced, so that's our final choice.

FINAL VERSION OF THE PET CHARACTER

HOWDY! I'LL BE YOUR GUIDE THROUGH THE REST OF THIS BOOK.

←These are his horns.

2 SHAPE THE FIGURE, KEEPING BALANCE IN-MIND.

←He has a triangle mark on his chest.

←It's a common bat-like wing, but it has a unique shape as well.

3 FINISHED.

17

Let's Create Characters

Let's Illustrate Characters

SO FAR, WE'VE LEARNED HOW TO DRAW CHARACTERS FROM BASIC FIGURES. NOW LET'S PRACTICE! THE TEMPLATE BELOW IS JUST FOR YOU. FEEL FREE TO TRY IT!

You can either photocopy . . .

COPY

. . . or trace over this page!

Template

Draw a boy of four to five head-lengths high.

His face is already done. Using the basic figure as a base, try drawing the rest of his body.

YOU CAN DRAW DIRECTLY ON THIS BOOK.

Final Result

As an example, here is a boy drawn using the template.

←The shirt fits tightly along the shoulder line.

←Wrinkles are added around the armpits.

→ Wrinkles are added to the area buckled by the belt.

←The pants sag around the knees.

Wrinkles are added around the ankle of the boots. →

Drawing Process:
Digital Color Illustration

① FORMULATE THE THEME AND COMPOSITION OF THE ILLUSTRATION.

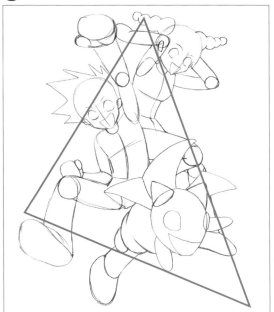

Characters Used: the "basic figure" boy and girl, with their pet.

Theme: Compose a very action-packed illustration. Sketch human characters in matching scale, and position them together to give a sense of their friendship.

- Production Environment
 - Software: Adobe Photoshop 7
 - Hardware: 700 MHz eMac Power PC G4 / 60GB internal hard drive, 640MB RAM (already expanded).
 - Scanner: EPSON GT-8300UF
 - Tablet: WACOM intuos2 i-620

Rough Structure: It's a tilted triangle. By enlarging the monster's face in the bottom-right, it works as the focal point for the entire picture.

② DRAW IN THE DETAIL.

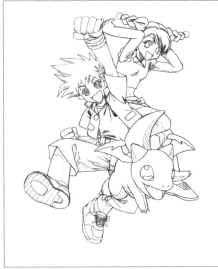

It's okay to keep the pencil lines, but to skip the extra cleaning steps, ink the draft with pen.

Original Illustration

Once you ink the image, scan it into Photoshop in color mode: "File" → "Import"

③ LAYER THE LINE DRAWING.

Photoshop and other graphics applications have a "layer" function; you can use it to stack and combine multiple images together, to generate a single image.

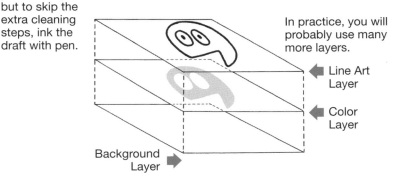

In practice, you will probably use many more layers.

◄ Line Art Layer

◄ Color Layer

Background Layer ►

"Layering" means generating a plane that separates your outlines from the rest of the image, like an animation cell. The main line art layer is placed on top; color layers are painted beneath it, and the background layer is at the bottom – see the figure above. This makes it easier to correct any mistakes later on.

After the original drawing is inked and scanned, it is cleaned with the eraser tool. Observe the line drawing after level adjustment.

THIS WON'T WORK AS A CELL DRAWING YET. THE WHITE AREA NEEDS TO BE TRANSPARENT!

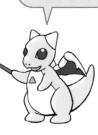

In other words, the gray area of the scanned illustration is not transparent.

The drawn lines must be extracted and pasted onto a new layer on top of the background layer.

❹ GET READY TO COLOR.

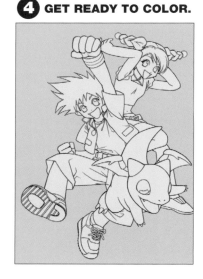

Delete any leftover lines in the background layer, and then paint over with a light green. This not only helps with colors but also makes it easier on the eyes. Paint the characters separately by the same procedure.

The line drawing is now extracted and painted in black.

Layering Procedure

- Click on either "Red," "Green" or "Blue" from the Channel window.

- Drag and drop into the button under the palette that reads "Load channel as selection."

- While you still have the image selected, invert it with "Select"—"Inverse."

- Generate a new layer from the Layer window, select a color of your choice (black is selected for this example), and paint over the selected area.

- This procedure is done using Photoshop 7 running on Mac OSX. If you're using Windows or other software, it will be somewhat different. Regardless, what we're trying to achieve is to generate a line-only drawing. Keep that in mind!

❺ COLOR!

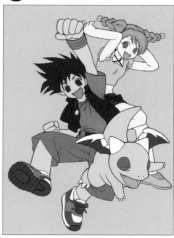

Fill in the base colors. Divide the image into different layers as you plan out the overall color distribution.

Using something like the path tool, add shadows.

After the finishing touches, such as highlights, are complete, place your pre-prepared background image behind it— and there we have the finished image.

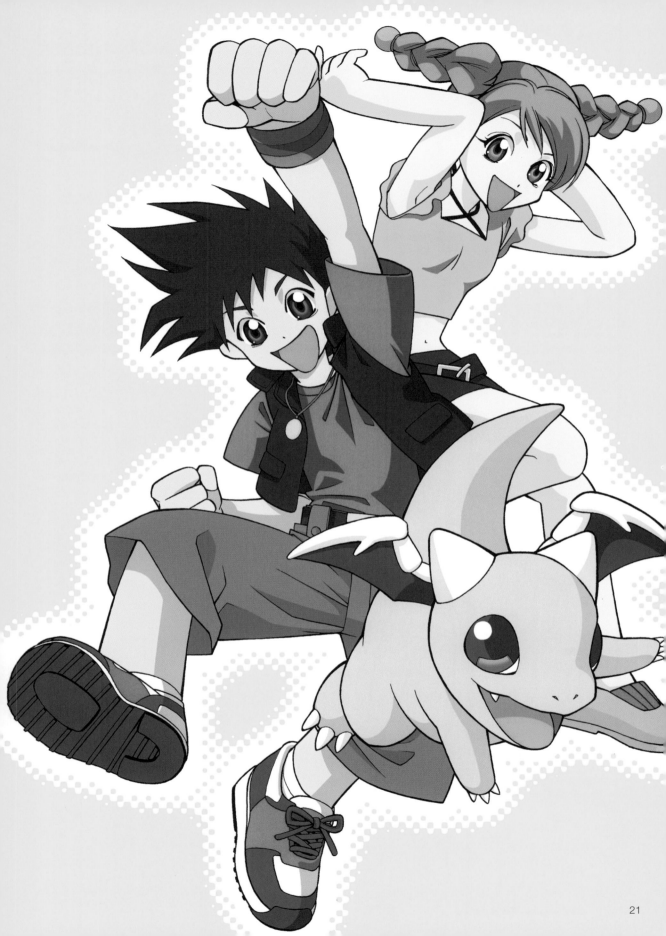

Let's Create Some Characters!

Illustrating Human-Sized Characters!

THEME 1 ## Western-Style Medieval Characters

In Japan, the phrase "Sword and Magic" refers to medieval fantasy. The origin of the phrase is unknown, but it means that as long as knights and magic are present, it's a medieval fantasy. Let's create characters using "Sword and Magic" as our theme.

STEP 1. Capturing the Concepts of the Central Characters

➡ First, draw a rough human-body doll. While you sketch, think of a character who fits the theme. This step comes before you can decide on the hairstyle or the costume.

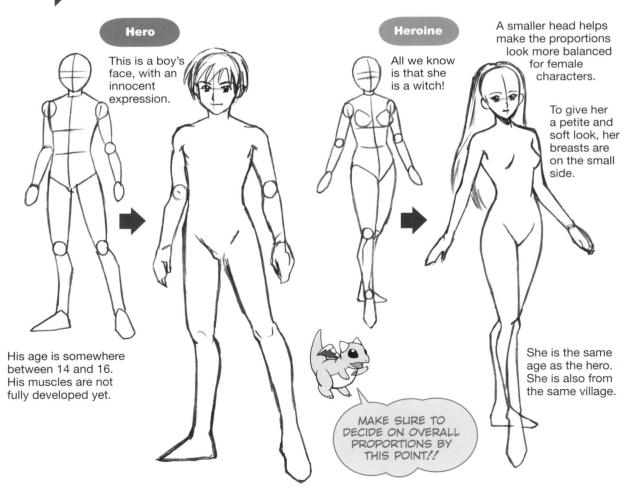

Hero

This is a boy's face, with an innocent expression.

Heroine

All we know is that she is a witch!

A smaller head helps make the proportions look more balanced for female characters.

To give her a petite and soft look, her breasts are on the small side.

His age is somewhere between 14 and 16. His muscles are not fully developed yet.

She is the same age as the hero. She is also from the same village.

MAKE SURE TO DECIDE ON OVERALL PROPORTIONS BY THIS POINT*!!*

STEP 2. Establishing the Facial Expressions

First impressions are very important for manga! Now we'll create distinct looks for your main characters. Sketch as much as you can, until you feel comfortable with each expression!

How to draw a head

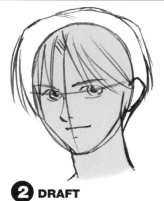

1 OUTLINE

First, establish the overall size; draw lines in the center and at the eye level. This determines the positioning of the facial features.

2 DRAFT

The lower half of the circle pretty much forms the face on its own. Place a nose in the center line, and draw in the details.

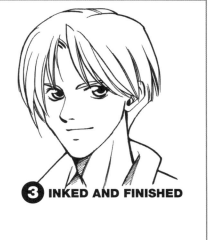

3 INKED AND FINISHED

Hero

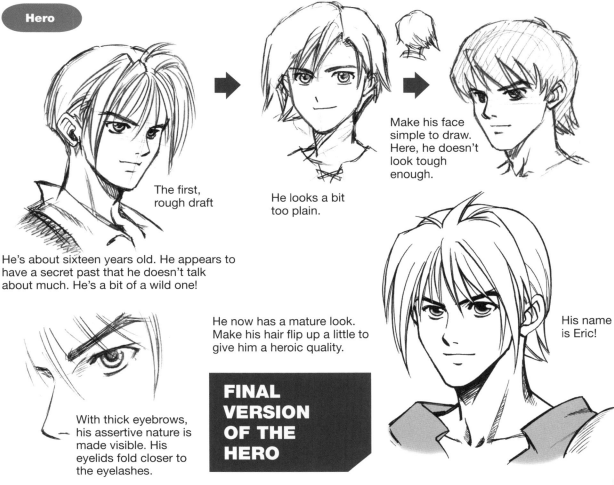

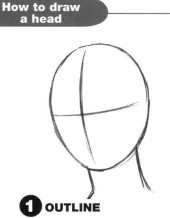

The first, rough draft

He's about sixteen years old. He appears to have a secret past that he doesn't talk about much. He's a bit of a wild one!

He looks a bit too plain.

Make his face simple to draw. Here, he doesn't look tough enough.

He now has a mature look. Make his hair flip up a little to give him a heroic quality.

With thick eyebrows, his assertive nature is made visible. His eyelids fold closer to the eyelashes.

FINAL VERSION OF THE HERO

His name is Eric!

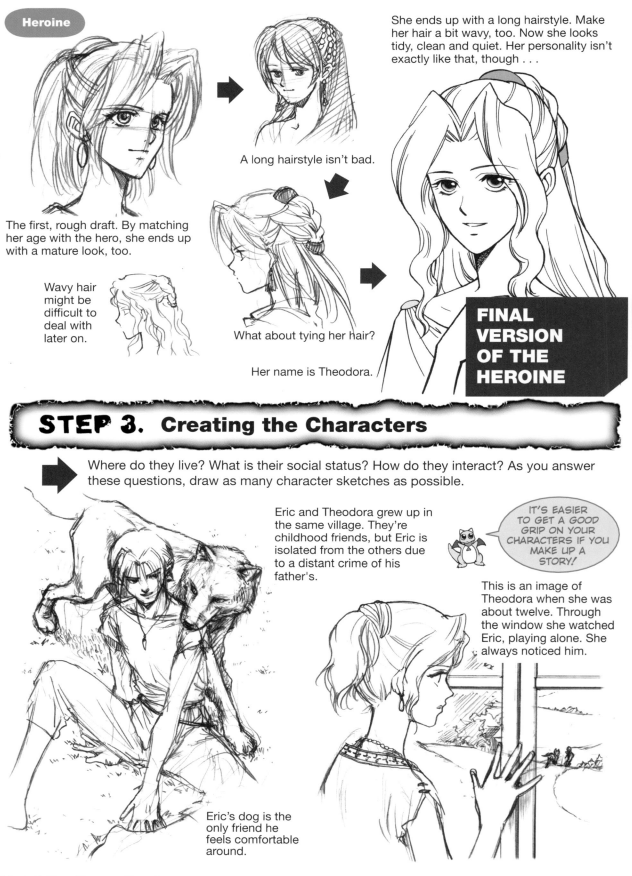

Heroine

The first, rough draft. By matching her age with the hero, she ends up with a mature look, too.

Wavy hair might be difficult to deal with later on.

A long hairstyle isn't bad.

What about tying her hair?

Her name is Theodora.

She ends up with a long hairstyle. Make her hair a bit wavy, too. Now she looks tidy, clean and quiet. Her personality isn't exactly like that, though . . .

FINAL VERSION OF THE HEROINE

STEP 3. Creating the Characters

Where do they live? What is their social status? How do they interact? As you answer these questions, draw as many character sketches as possible.

Eric and Theodora grew up in the same village. They're childhood friends, but Eric is isolated from the others due to a distant crime of his father's.

Eric's dog is the only friend he feels comfortable around.

IT'S EASIER TO GET A GOOD GRIP ON YOUR CHARACTERS IF YOU MAKE UP A STORY!

This is an image of Theodora when she was about twelve. Through the window she watched Eric, playing alone. She always noticed him.

Eric brandishes
his sword.

Theodora ties
her hair.

well...

←Eric's regular
clothes. He's training
to be a swordsman.
Although he is
extremely skilled,
due to his father's
crime he is not
allowed to wear
a sword. He
is, however,
permitted to
carry daggers
and knives for
his own self-
defense. He's
always with his
buddy, the
wolf-dog.

←This is a costume Theodora
wears when she dances during the
spring harvest festival. She is from
the family of a priest, and is often
asked to participate in village
events.

She can recite a simple congratula-
tory song from memory. She is from
a fairly strict household, and is not
too happy about that. She forces
her way into Eric's company when
he sets out on a journey. Despite
her appearance, she is brave and
quick to take action.

**WHY
ARE YOU
FOLLOWING
ME?!**

**IT JUST SO
HAPPENS THAT I'M
HEADING IN THE
SAME DIRECTION.**

Eric laughs when
he is with his dog.

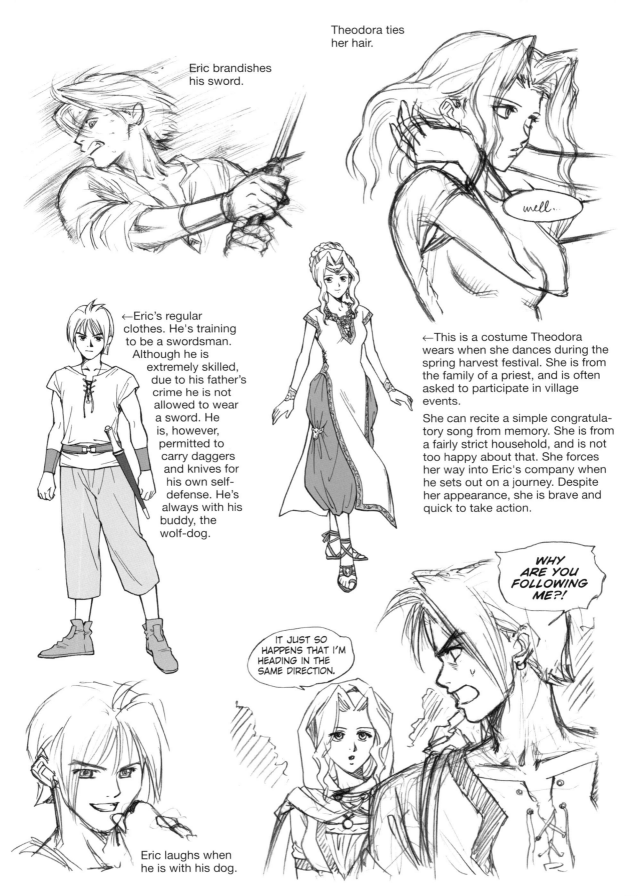

STEP.4 Fully-Clothed People

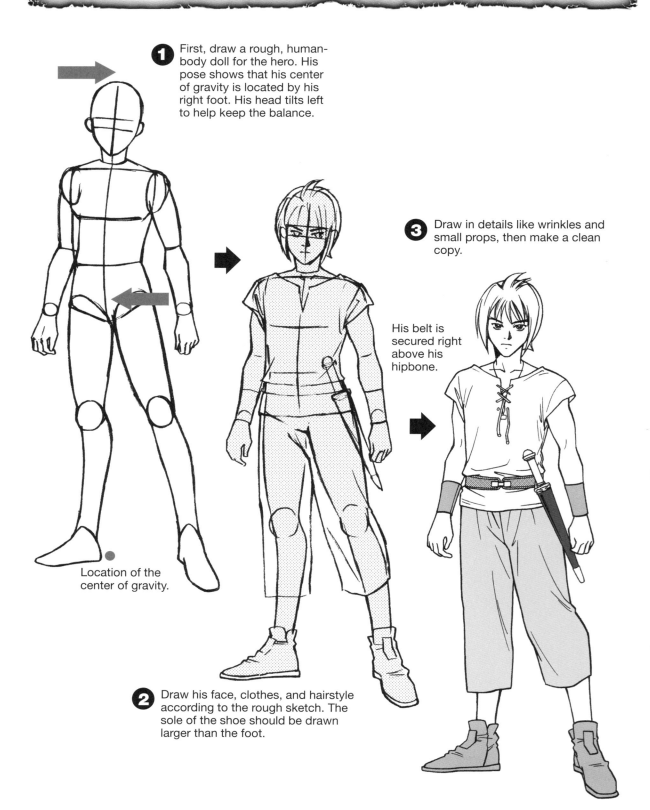

1 First, draw a rough, human-body doll for the hero. His pose shows that his center of gravity is located by his right foot. His head tilts left to help keep the balance.

Location of the center of gravity.

2 Draw his face, clothes, and hairstyle according to the rough sketch. The sole of the shoe should be drawn larger than the foot.

3 Draw in details like wrinkles and small props, then make a clean copy.

His belt is secured right above his hipbone.

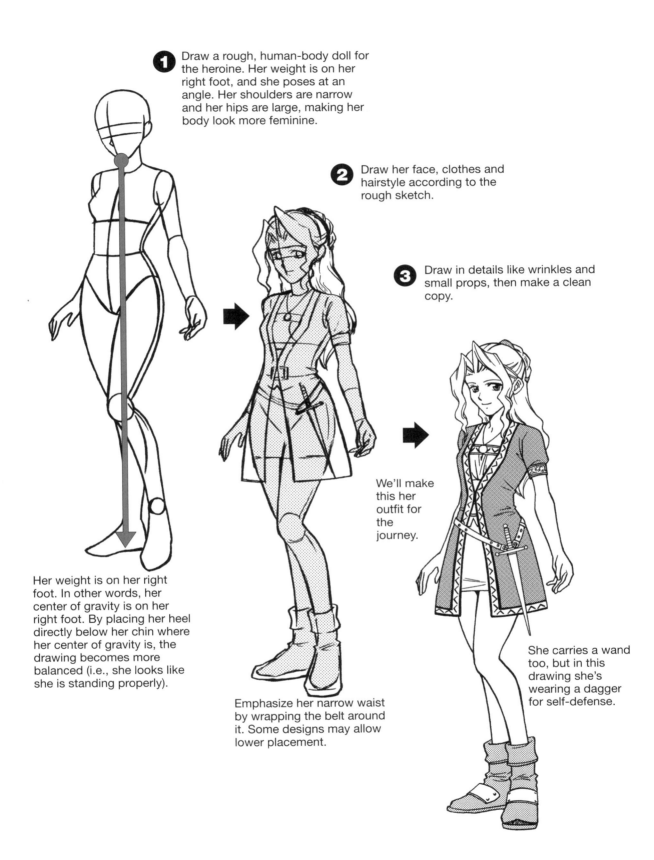

1 Draw a rough, human-body doll for the heroine. Her weight is on her right foot, and she poses at an angle. Her shoulders are narrow and her hips are large, making her body look more feminine.

2 Draw her face, clothes and hairstyle according to the rough sketch.

3 Draw in details like wrinkles and small props, then make a clean copy.

We'll make this her outfit for the journey.

Her weight is on her right foot. In other words, her center of gravity is on her right foot. By placing her heel directly below her chin where her center of gravity is, the drawing becomes more balanced (i.e., she looks like she is standing properly).

Emphasize her narrow waist by wrapping the belt around it. Some designs may allow lower placement.

She carries a wand too, but in this drawing she's wearing a dagger for self-defense.

Let's Create Some Characters!

Let's Draw Western-Style Medieval Characters!

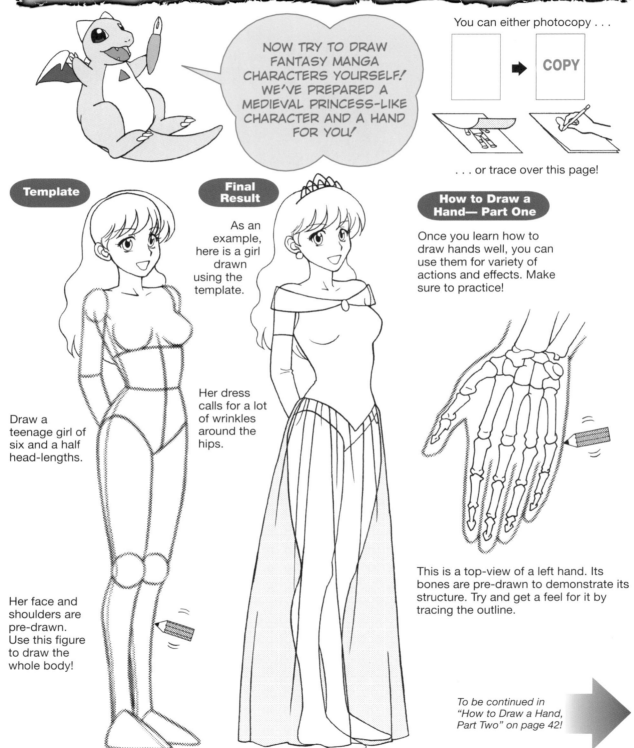

NOW TRY TO DRAW FANTASY MANGA CHARACTERS YOURSELF! WE'VE PREPARED A MEDIEVAL PRINCESS-LIKE CHARACTER AND A HAND FOR YOU!

You can either photocopy . . .

COPY

. . . or trace over this page!

Template

Final Result

As an example, here is a girl drawn using the template.

Her dress calls for a lot of wrinkles around the hips.

Draw a teenage girl of six and a half head-lengths.

Her face and shoulders are pre-drawn. Use this figure to draw the whole body!

How to Draw a Hand— Part One

Once you learn how to draw hands well, you can use them for variety of actions and effects. Make sure to practice!

This is a top-view of a left hand. Its bones are pre-drawn to demonstrate its structure. Try and get a feel for it by tracing the outline.

To be continued in "How to Draw a Hand, Part Two" on page 42!

Drawing Process:
Digital Color Illustration

❶ DRAW A ROUGH DRAFT.

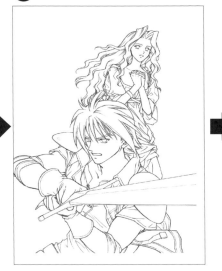

From many rough drafts, we selected one with a sense of motion. The hero's face is placed in the center. Overall, it's composed to give the impression that the image is moving up toward the castle.

❷ SCAN THE LINE DRAWING.

After the draft is inked, it is scanned. Then its color is adjusted and the lines are cleaned. Now the line drawing is layered*.

See pages 19 and 20 for reference.
Printing reslution is set at 350 d.p.i.

Line drawing of the background

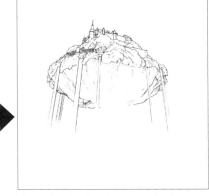

To make the background look soft, the penciled image is scanned.

- Production Environment
 Software: Photoshop 7
 The hardware, printer, scanner and tablet are the same as page 19.

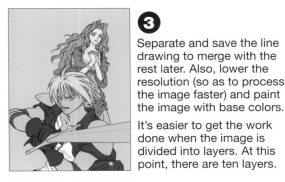

❸

Separate and save the line drawing to merge with the rest later. Also, lower the resolution (so as to process the image faster) and paint the image with base colors.

It's easier to get the work done when the image is divided into layers. At this point, there are ten layers.

❹

As the "color adjustment" and "color replacement" process is repeated over and over, try and reach the ideal color combination.

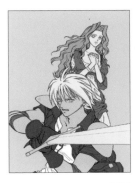

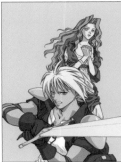

❺

Create a layer for each color and add shadows. It's easier to work on them if a "layer set" for linked layers is created.

One way to be efficient is to merge the completed layers as each layer is finished

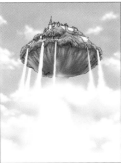

❻

Color the background image.

The work is done once the finished characters are copied and pasted onto this image.

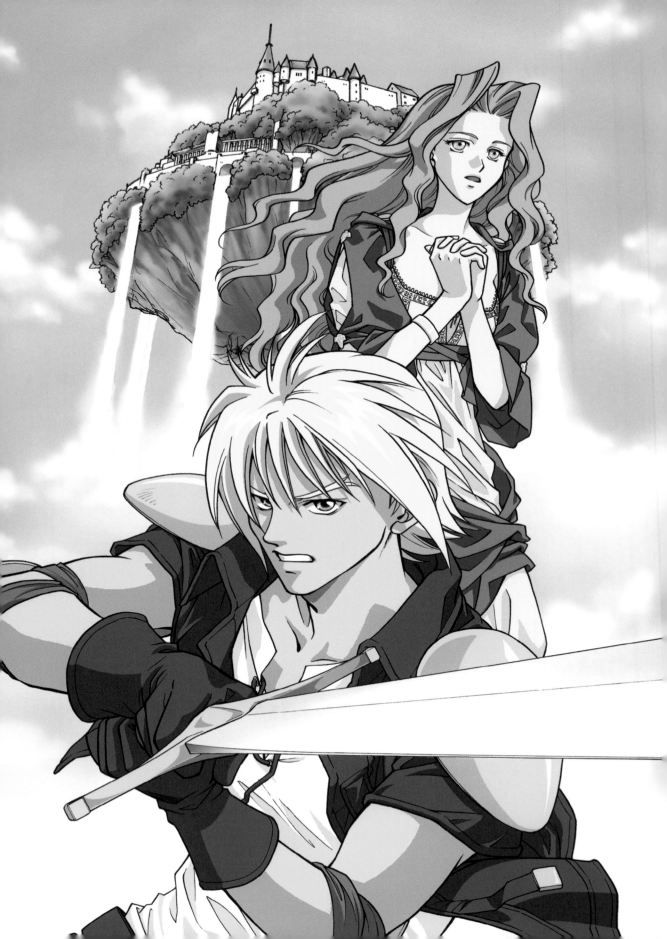

THEME 2 SCI-FI STYLE

The purest branch of fantasy is the Western medieval style. Nowadays, however, there are newer sub-branches that involve outer space, time travel, and genetic science. Let's create characters that are used in "sci-fan" manga!

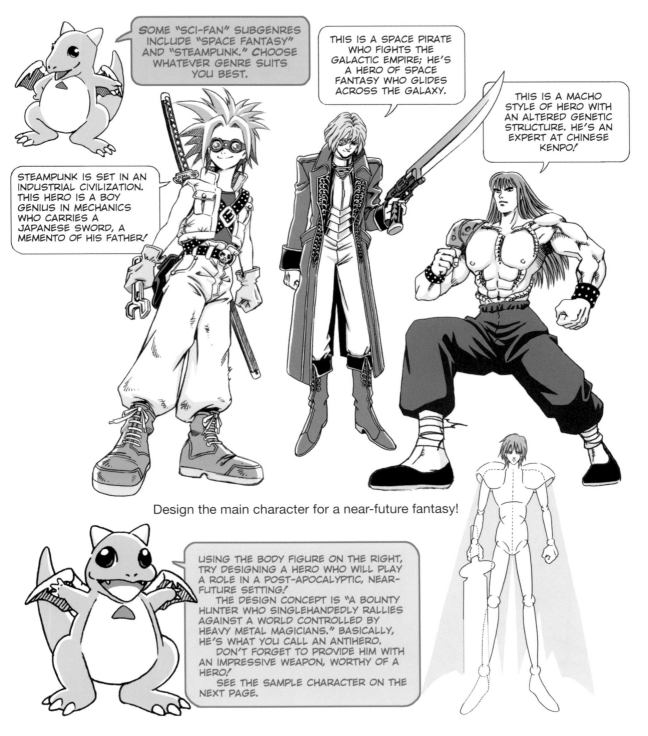

SOME "SCI-FAN" SUBGENRES INCLUDE "SPACE FANTASY" AND "STEAMPUNK." CHOOSE WHATEVER GENRE SUITS YOU BEST.

THIS IS A SPACE PIRATE WHO FIGHTS THE GALACTIC EMPIRE; HE'S A HERO OF SPACE FANTASY WHO GLIDES ACROSS THE GALAXY.

THIS IS A MACHO STYLE OF HERO WITH AN ALTERED GENETIC STRUCTURE. HE'S AN EXPERT AT CHINESE KENPO!

STEAMPUNK IS SET IN AN INDUSTRIAL CIVILIZATION. THIS HERO IS A BOY GENIUS IN MECHANICS WHO CARRIES A JAPANESE SWORD, A MEMENTO OF HIS FATHER!

Design the main character for a near-future fantasy!

USING THE BODY FIGURE ON THE RIGHT, TRY DESIGNING A HERO WHO WILL PLAY A ROLE IN A POST-APOCALYPTIC, NEAR-FUTURE SETTING!
THE DESIGN CONCEPT IS "A BOUNTY HUNTER WHO SINGLEHANDEDLY RALLIES AGAINST A WORLD CONTROLLED BY HEAVY METAL MAGICIANS." BASICALLY, HE'S WHAT YOU CALL AN ANTIHERO.
DON'T FORGET TO PROVIDE HIM WITH AN IMPRESSIVE WEAPON, WORTHY OF A HERO!
SEE THE SAMPLE CHARACTER ON THE NEXT PAGE.

His age is somewhere between twenty and twenty-five years.

DRAW A CONCEPT SKETCH FIRST!
DON'T WORRY TOO MUCH ABOUT THE DETAILS, BUT PUT MORE EFFORT INTO GENERATING A COOL SILHOUETTE FOR HIS DESIGN.

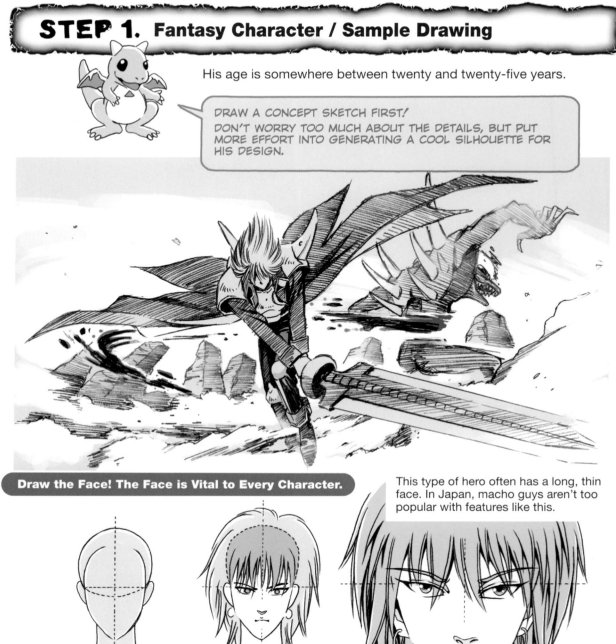

Draw the Face! The Face is Vital to Every Character.

This type of hero often has a long, thin face. In Japan, macho guys aren't too popular with features like this.

Make his head somewhat big, and give some decent volume to his hair.

Give him a pointy chin and a fierce-looking face. But remember, an antihero isn't a villain. Make sure he doesn't have an evil appearance!

His long, slim eyes slope upward. Add long eyelashes to give him a somewhat troubled look.

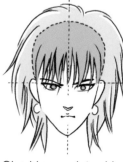

Although it's a fantasy, give him some modern-looking clothes and accessories.

STEP 2. Determining the Body Proportion

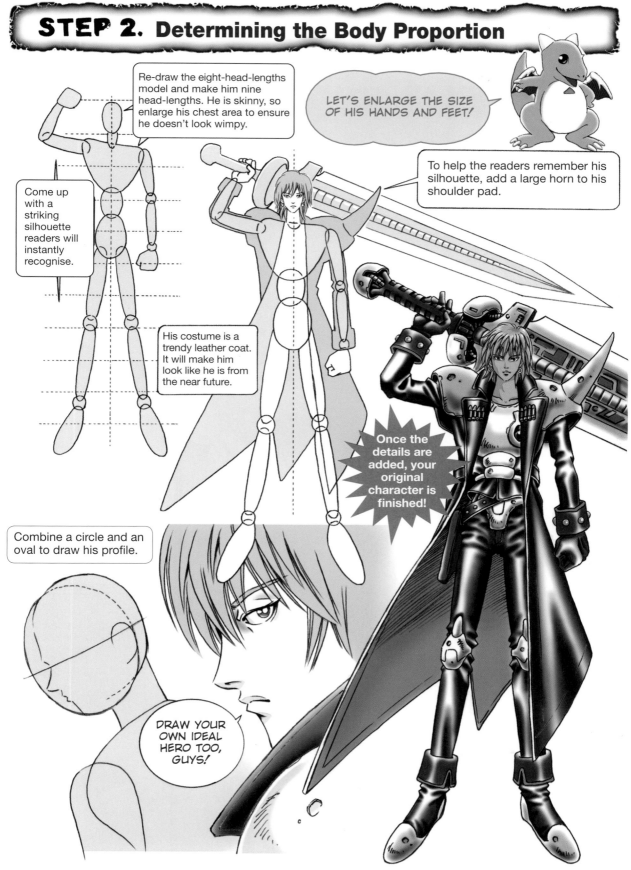

Re-draw the eight-head-lengths model and make him nine head-lengths. He is skinny, so enlarge his chest area to ensure he doesn't look wimpy.

LET'S ENLARGE THE SIZE OF HIS HANDS AND FEET!

To help the readers remember his silhouette, add a large horn to his shoulder pad.

Come up with a striking silhouette readers will instantly recognise.

His costume is a trendy leather coat. It will make him look like he is from the near future.

Once the details are added, your original character is finished!

Combine a circle and an oval to draw his profile.

DRAW YOUR OWN IDEAL HERO TOO, GUYS!

STEP 3. Let's Create a Heroine!

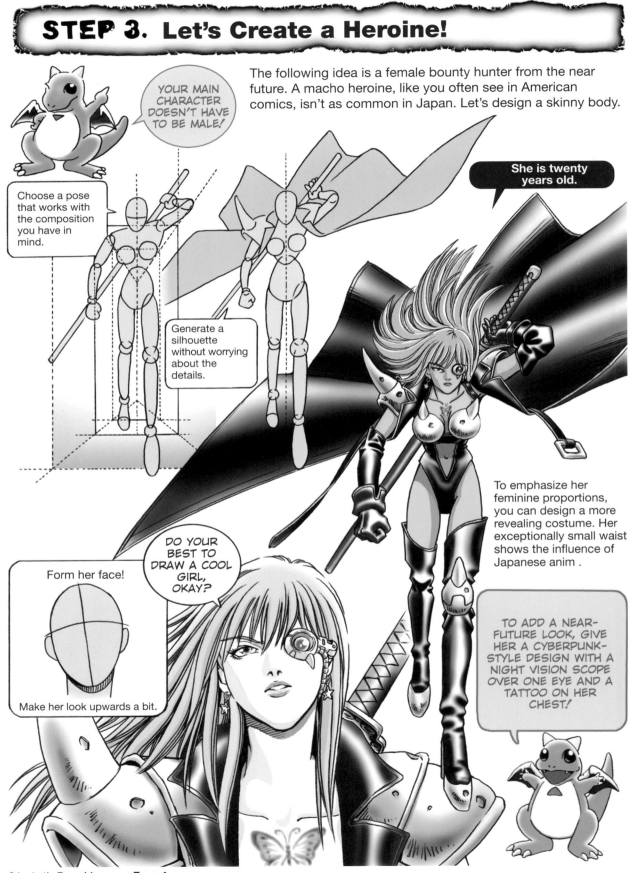

The following idea is a female bounty hunter from the near future. A macho heroine, like you often see in American comics, isn't as common in Japan. Let's design a skinny body.

YOUR MAIN CHARACTER DOESN'T HAVE TO BE MALE!

She is twenty years old.

Choose a pose that works with the composition you have in mind.

Generate a silhouette without worrying about the details.

To emphasize her feminine proportions, you can design a more revealing costume. Her exceptionally small waist shows the influence of Japanese anim.

DO YOUR BEST TO DRAW A COOL GIRL, OKAY?

Form her face!

Make her look upwards a bit.

TO ADD A NEAR-FUTURE LOOK, GIVE HER A CYBERPUNK-STYLE DESIGN WITH A NIGHT VISION SCOPE OVER ONE EYE AND A TATTOO ON HER CHEST!

SCI-FI STYLE
Let's Illustrate Characters!

THE PREMISE FOR THIS ILLUSTRATION IS AN ENCOUNTER BETWEEN THE ALOOF BOUNTY HUNTER AND A FAIRY.

USING SOFT COLORS, LET'S DRAW A SCENE WHERE THE HERO, AN OUTLAW WHO OPENS HIS HEART TO NO ONE, TALKS WITH A FAIRY FOR THE FIRST TIME. *MAKOTO* OF BIG MOUTH FACTORY WILL WORK ON THIS DIGITALLY, USING PHOTOSHOP.

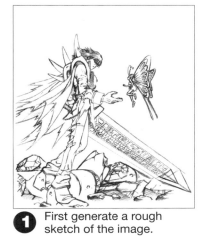

1 First generate a rough sketch of the image.

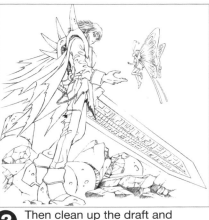

2 Then clean up the draft and perfect the line drawing.

3 LAYER THE LINE DRAWING.

The goal is to give the illustration a watercolor feel. Layer the line drawing and place it on top. Select a few lines from the line drawing with a selection tool, then from the "Select" menu, select "Similar." This will select all lines in the line drawing. Copy the selection and paste it to a new layer. Paint over the background with white.

THE FINISHED ILLUSTRATION IS ON THE NEXT PAGE.

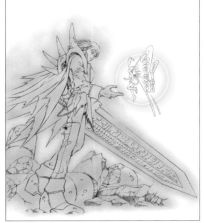

4 Create a new layer and start coloring. Use a light purplish gray as a base. It will establish the overall fantasy-feel.

Layer
Line Drawing
Base Color
Background

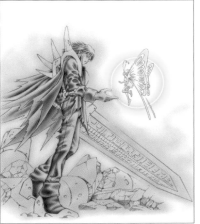

5 Using the "Multiply" draw mode, color the character over the base color. Note that MAKOTO does not create many layers.

Layer
Line Drawing
Clothes 2
Clothes 1
Skin
Background

6 The idea is to use soft, unsaturated colors and to put the image together using complementary tones. The character's coloring is complete at this point. All that's left to finish is the background.

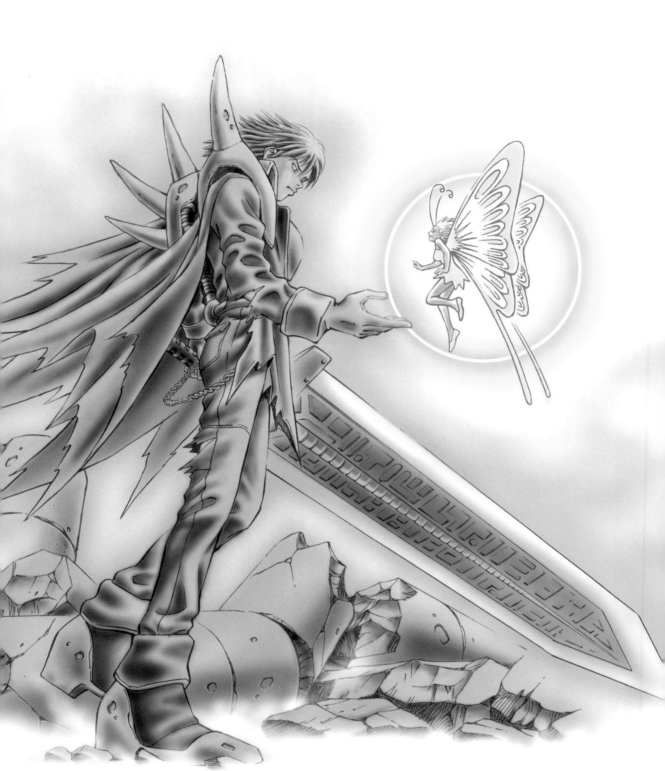

 # Asian-Style Characters

By Asia, we mean in particular *East* Asia—mainly China, Japan, India and the Philippines. Let's create characters from an Eastern-themed world.

STEP 1. Capturing the Main Character Concepts

➡️ The story is set in a parallel universe with an ancient Chinese motif. It concerns a Japanese high school girl who gets lost and ends up meeting a half-monster boy, and how they share and confront their fate together.

Heroine **Initial rough drafts**

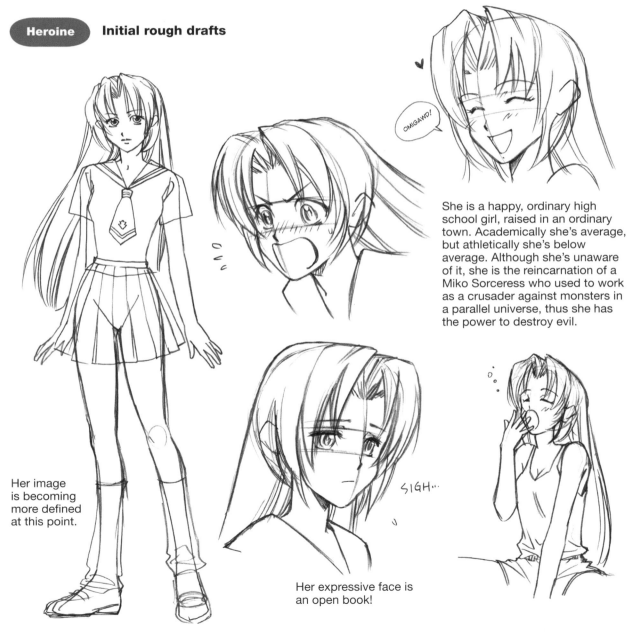

OMIGAWD!

She is a happy, ordinary high school girl, raised in an ordinary town. Academically she's average, but athletically she's below average. Although she's unaware of it, she is the reincarnation of a Miko Sorceress who used to work as a crusader against monsters in a parallel universe, thus she has the power to destroy evil.

Her image is becoming more defined at this point.

SIGH...

Her expressive face is an open book!

Supporting Hero

A half-monster (half-human and half-monster), whom the heroine meets in the parallel universe.

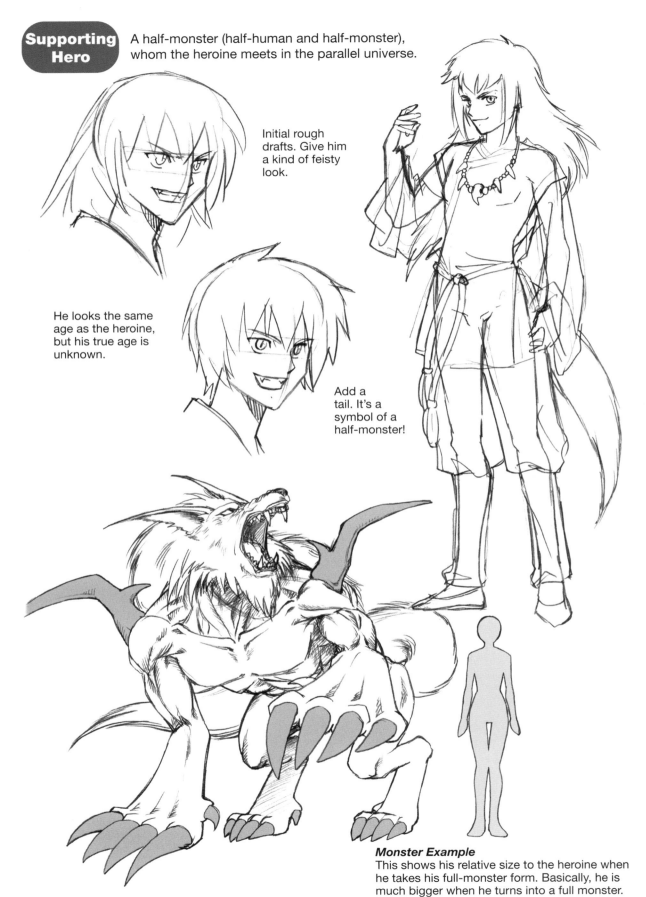

Initial rough drafts. Give him a kind of feisty look.

He looks the same age as the heroine, but his true age is unknown.

Add a tail. It's a symbol of a half-monster!

Monster Example
This shows his relative size to the heroine when he takes his full-monster form. Basically, he is much bigger when he turns into a full monster.

STEP 2. Developing the Appearance

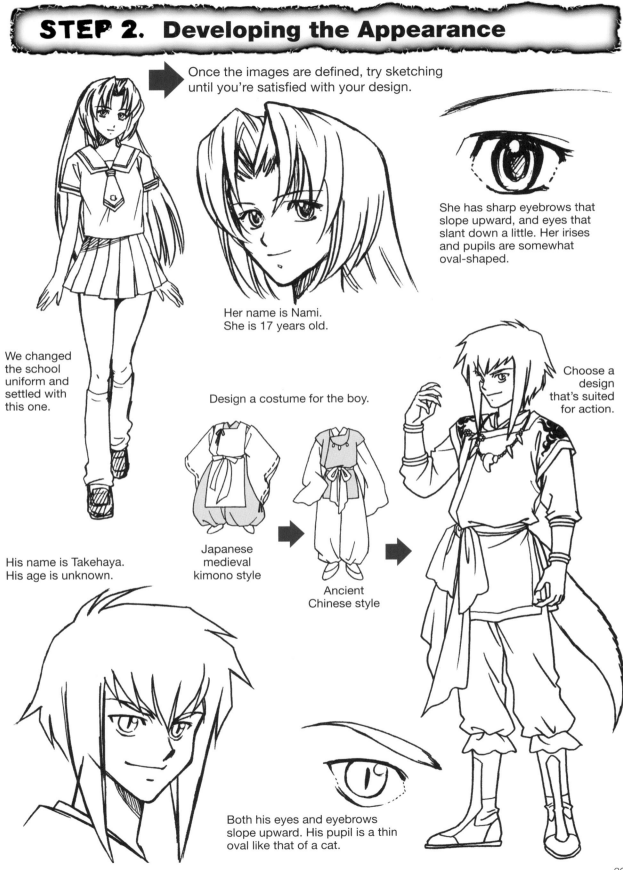

Once the images are defined, try sketching until you're satisfied with your design.

She has sharp eyebrows that slope upward, and eyes that slant down a little. Her irises and pupils are somewhat oval-shaped.

Her name is Nami. She is 17 years old.

We changed the school uniform and settled with this one.

Design a costume for the boy.

Choose a design that's suited for action.

His name is Takehaya. His age is unknown.

Japanese medieval kimono style

Ancient Chinese style

Both his eyes and eyebrows slope upward. His pupil is a thin oval like that of a cat.

STEP 3. How to Draw Humans

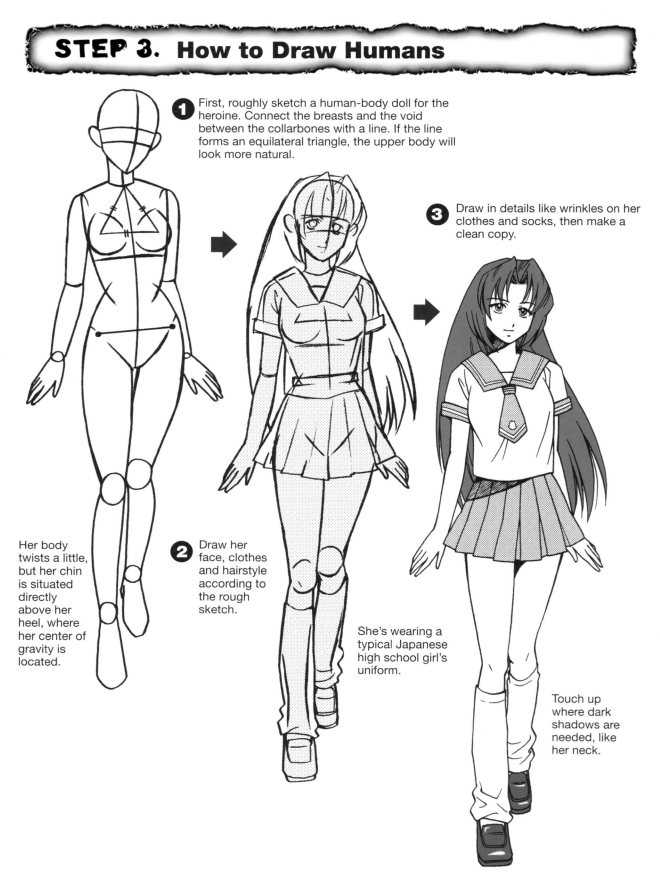

1 First, roughly sketch a human-body doll for the heroine. Connect the breasts and the void between the collarbones with a line. If the line forms an equilateral triangle, the upper body will look more natural.

3 Draw in details like wrinkles on her clothes and socks, then make a clean copy.

Her body twists a little, but her chin is situated directly above her heel, where her center of gravity is located.

2 Draw her face, clothes and hairstyle according to the rough sketch.

She's wearing a typical Japanese high school girl's uniform.

Touch up where dark shadows are needed, like her neck.

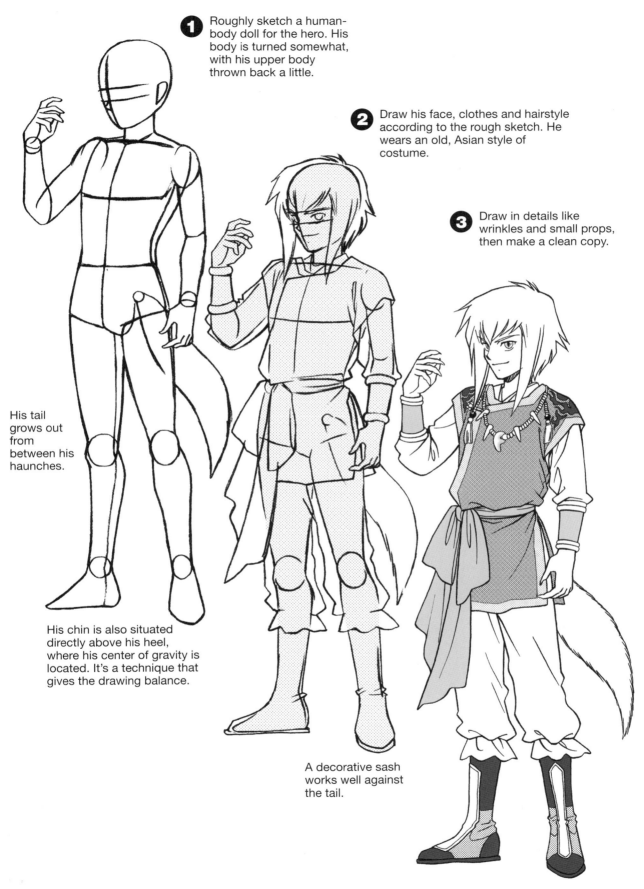

1 Roughly sketch a human-body doll for the hero. His body is turned somewhat, with his upper body thrown back a little.

2 Draw his face, clothes and hairstyle according to the rough sketch. He wears an old, Asian style of costume.

3 Draw in details like wrinkles and small props, then make a clean copy.

His tail grows out from between his haunches.

His chin is also situated directly above his heel, where his center of gravity is located. It's a technique that gives the drawing balance.

A decorative sash works well against the tail.

Let's Draw Asian-Style Characters!

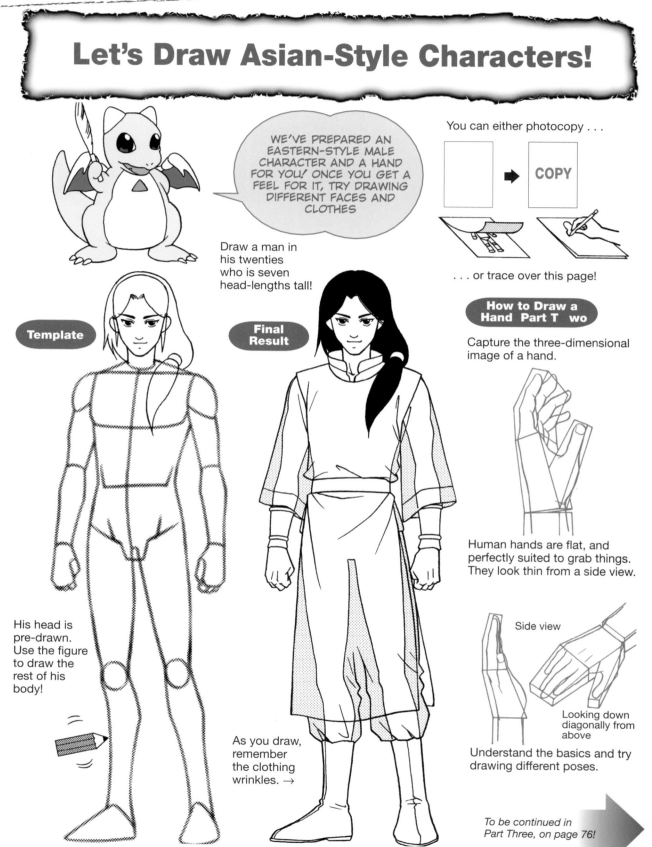

WE'VE PREPARED AN EASTERN-STYLE MALE CHARACTER AND A HAND FOR YOU! ONCE YOU GET A FEEL FOR IT, TRY DRAWING DIFFERENT FACES AND CLOTHES

You can either photocopy . . .

COPY

. . . or trace over this page!

Draw a man in his twenties who is seven head-lengths tall!

How to Draw a Hand Part Two

Capture the three-dimensional image of a hand.

Template

Final Result

His head is pre-drawn. Use the figure to draw the rest of his body!

Human hands are flat, and perfectly suited to grab things. They look thin from a side view.

Side view

Looking down diagonally from above

As you draw, remember the clothing wrinkles. →

Understand the basics and try drawing different poses.

To be continued in Part Three, on page 76!

Let's Create Characters!

Drawing Process: Digital Color Illustration
Asian Character Edition

1 **DRAW A RO GH DRAFT.**

Illustrate the two characters in Chinese Kenpo poses. Show a full figure and a knee shot. Let's bring out that Asian quality with the use of colors and patterns.

2 **IN THE LINE DRAWING.**

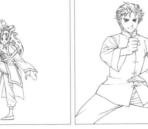

Trace each character separately. Once they're colored, they'll be composed together.

3 Scan and layer the line drawing. Save a low-resolution file under a different name and start coloring it. The production environment is the same as the one specified in page 1 .

4 **FILL IN THE BASE COLOR.**

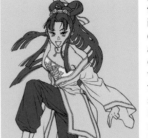

First, separate the girl's image into different parts and color each. Since we're coloring this in anim style, the blending mode of each layer should be "Normal."

5 By paying attention to how you stack the layers, and by starting at the top layers, you can color aggressively like this!

6 The girl's base colors are finished at this point. You should complete details like her accessories and sword ahead of time.

Merge all colored layers together and raise the image resolution before merging them with the line drawing layer. Delete the low-res version of the line drawing temporarily used for fast processing.

● Next, color the boy. As with the girl, fill in the base color first, then establish a separate layer with patterns for his clothes; follow the same procedure.

8 **FILL IN THE BASE COLOR.**

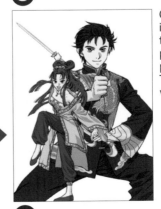

Combine the separate images of the boy and the girl by copying and pasting. Adjust their positions and save. Then place the gray net with "Multiply."

9 **FINISHING!**

Complete the characters by adjusting the color and adding highlights— then combine the image with a background, and you're done.

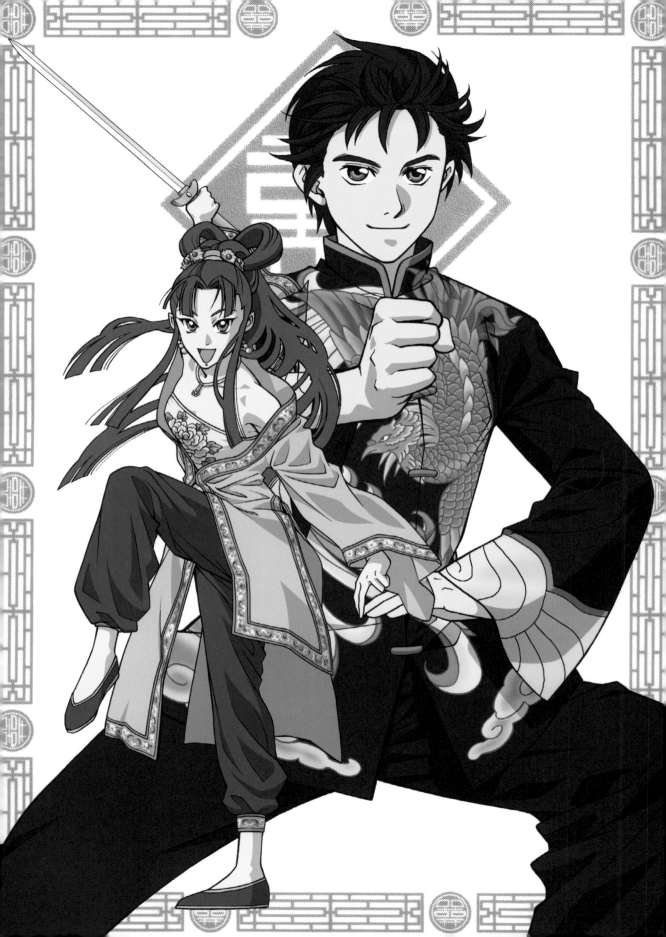

Let's Establish our World!

In fantasy manga, it's critical for the world to feel real. Here's how to drag your readers into an alternate reality!

Creating a Western Medieval World!

The Environment Where the Main Characters Live

This is the village where the main characters grew up. With its ravines and lakes, it's a beautiful, natural world.

Its concept comes from inland Central Europe. It has four seasons: a chilly spring and autumn, a refreshing summer with strong sun, and a freezing winter.

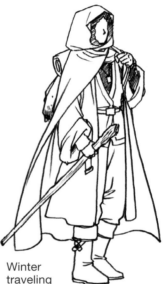

Winter traveling garb

This is Eric's home. It's pretty small for a house!

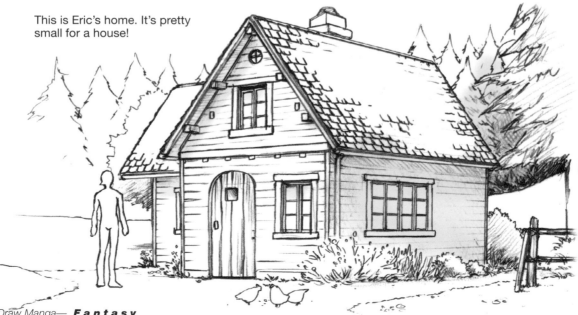

Stores and houses line the street. Travelers and merchants come and go. This forms the center of the village.

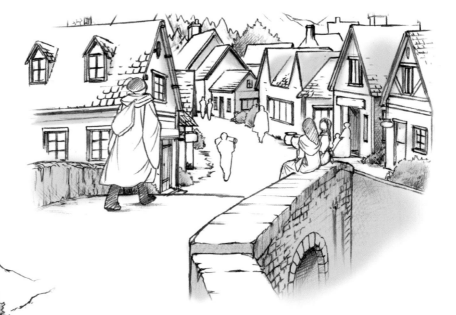

The main business here is livestock grazing. Some inhabitants farm the land, but it's mainly done for self-sustenance.

Theodora is taking care of the rabbit-goats.

In the center of the village, there is an inn with a bar.

It serves as an information post for travelers, as well as a village lounge.

YOU BOYS, ALWAYS SNEAKING IN HERE!

GET OUT!! NOW!!

WHOOPS!

RUN!!!

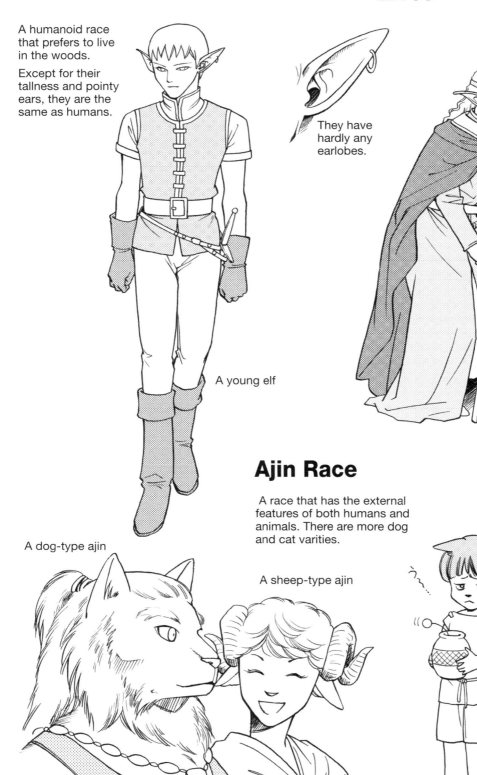

Elves

A humanoid race that prefers to live in the woods.

Except for their tallness and pointy ears, they are the same as humans.

They have hardly any earlobes.

As they age, their ears begin to slope down.

A young elf

An elderly elf

Ajin Race

A race that has the external features of both humans and animals. There are more dog and cat varities.

A dog-type ajin

A sheep-type ajin

A cat-type ajin kid, scolded by her parents. There's some kind of creature in her pot . . .

Goblins

They mainly work in the mines. A noisy bunch, without exception!

Fairies

Their height is about 1 cm, and they have insect-like wings. Their personalities are usually childish. Their race depends on where they live.

A forest fairy

Cats

A cat's tail will flash as if on fire. The cat's age and sex can be determined by the color of its fire.

Main Character Wardro es

We'll gradually put their costumes together as they travel.

Theodora Final Version

Eric's sword and Theodora's wand are items they obtain during their adventure.

Early on, they both lack skill and are pretty much defenseless. (See previous pages for reference.)

Eric Final Version

Eric wears armor too, which will be introduced in Chapter 4.

A swords-man-like outfit with a long sword.

A witch-like outfit with a robe and wand.

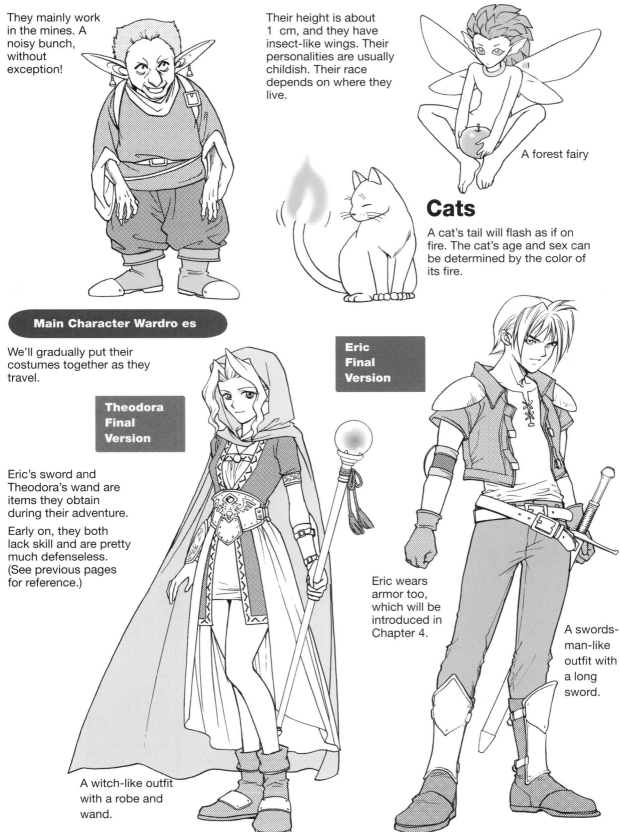

Floating Castle

During their journey, the protagonists visit this castle to improve their skills. More like a fortress city than a castle, it is constantly afloat in midair. It is the hub of the country of witches and wizards who believe in Eluke, Holy Goddess of Ether. Above the castle is a shrine; at the bottom is a dock for aircraft, the only method of transportation.

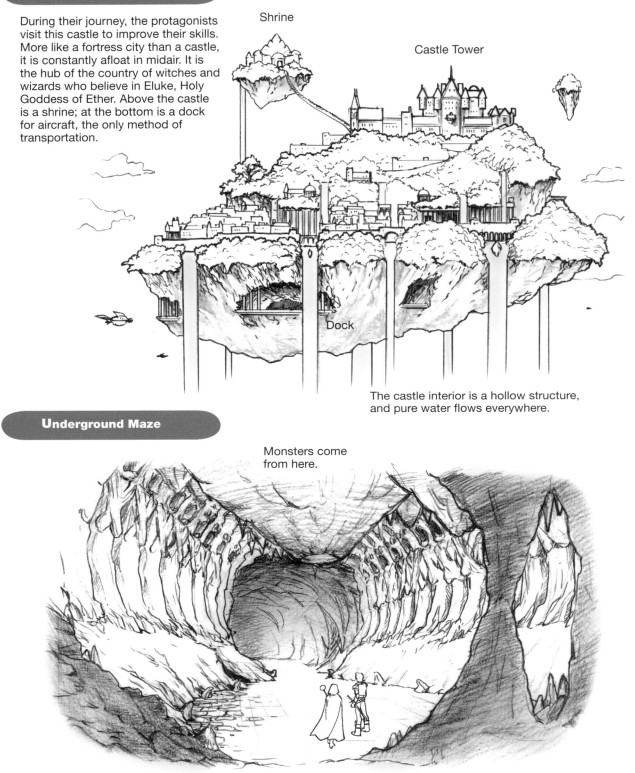

Shrine

Castle Tower

Dock

The castle interior is a hollow structure, and pure water flows everywhere.

Underground Maze

Monsters come from here.

Someone built a castle with a maze under the eastern desert. It's full of evil spirits; just walking through it fills a person with anxiety and fear. Its interior is complex and loaded with traps.

There are many powerful monsters with attributes like "Earth," "Fire," and "Darkness." They may be there to eliminate intruders, or they may be protecting something secret while slumbering deep beneath!

Let's Establish our World!

Let's Illustrate our Western Medieval World in Color!
Drawing Process: Digital Color Illustration

1 SKETCH THE IMAGE.

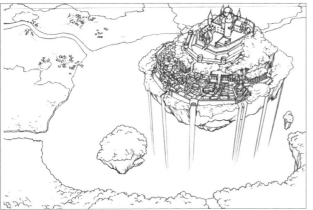

Draw the floating castle from page 0. From the expanse of the lake and the streets below, the castle's scale can be easily understood.

> IT'S EASIER TO WORK ON A BIRD'S-EYE VIEW COMPOSITION IF YOU DRAW PARSING LINES LIKE THIS!

2 SCAN THE IMAGE AND CLEAN THE LINE DRAWING.

- Production Environment Software: Photoshop 7

 The hardware, printer, scanner and tablet are the same as page 19.

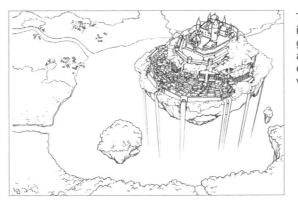

This is after the image is scanned in grayscale, color is adjusted, and the line drawing is cleaned with the eraser tool.

3 START COLORING!

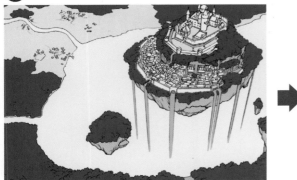

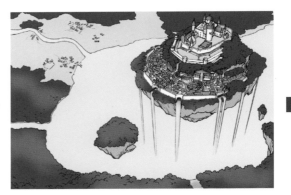

Roughly divide the image into different parts and paint with base colors. It's a good idea to use colors that help illustrate the mood you want.

The image is layered into "Lake" and "Woods," but you can further divide it as you color. Don't worry too much about any color that might jut outside the lines.

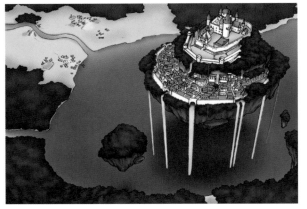

At this stage, coloring is mostly complete. Before finishing, merge the colored layers.

Once the colored layers are merged, add clouds, the surface of the lake, and water splashes in "Normal" mode. Checking the shade of the color, delete unnecessary lines.

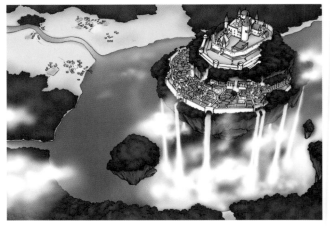

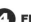 **FINISH AFTER LAYERS ARE MERGED.**

Image Illustration— Floating Castle (bird's-eye view)

The World of Science Fantasy!

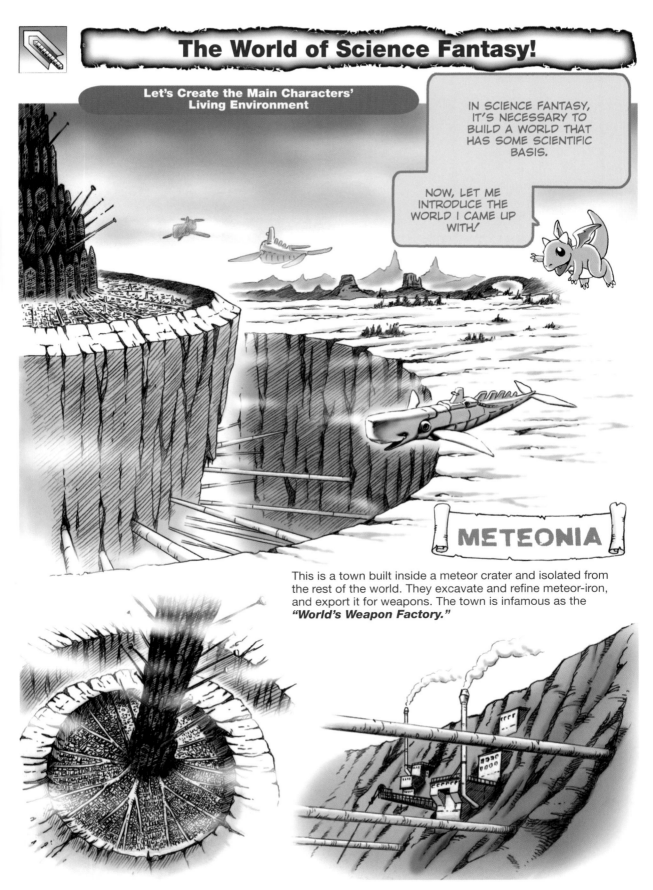

Let's Create the Main Characters' Living Environment

IN SCIENCE FANTASY, IT'S NECESSARY TO BUILD A WORLD THAT HAS SOME SCIENTIFIC BASIS.

NOW, LET ME INTRODUCE THE WORLD I CAME UP WITH!

METEONIA

This is a town built inside a meteor crater and isolated from the rest of the world. They excavate and refine meteor-iron, and export it for weapons. The town is infamous as the *"World's Weapon Factory."*

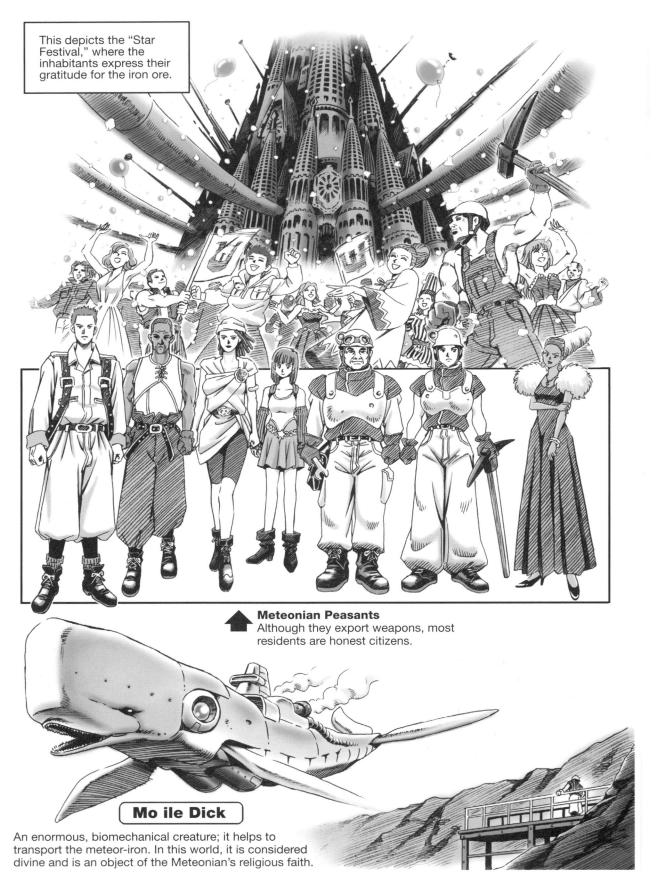

This depicts the "Star Festival," where the inhabitants express their gratitude for the iron ore.

Meteonian Peasants
Although they export weapons, most residents are honest citizens.

Mo ile Dick

An enormous, biomechanical creature; it helps to transport the meteor-iron. In this world, it is considered divine and is an object of the Meteonian's religious faith.

Every culture has a dark side: Meteonia has young, violent gangs without steady jobs. The streets are littered with the homeless . . .

Meteonia has an unusually large slum district.

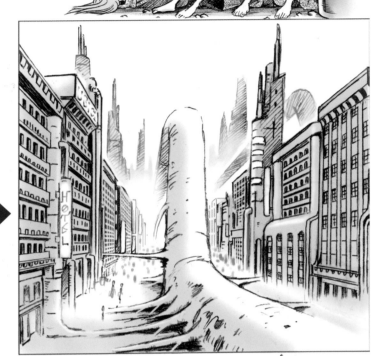

Biomechanical plants grow in the slum.

This is the root of a space-plant that lives on a human bio-energy called "anima."

Guelln Cathedral

The headquarters of Mystic Metalmasters is built around the space-plant. It has an "orbit elevator" that extends beyond the planet's atmosphere. (This design uses Antonio Gaudi's Sagrada Familia as its motif.)

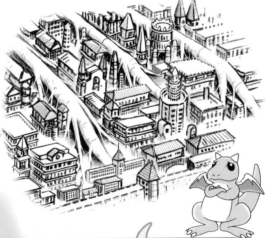

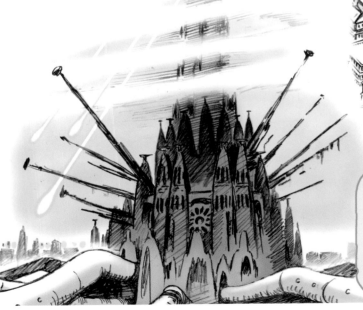

THE *GUELLN CATHEDRAL* IS POWERED BY THE BIO-ENERGY SUCKED OUT FROM THE METEONIANS. THE METEONIANS ARE CONTROLLED BY THE *MYSTIC METALMASTERS*, AND ARE NOT ALLOWED TO LEAVE THE CITY. THEIR BIO-ENERGY WILL CONTINUE TO BE SUCKED UNTIL THEY ARE MUMMIFIED. WHAT DO YOU THINK? A SCARY SETTING, HUH?

Mystic Metalmaster

They use questionable sorcery, control Mystic Metal Monsters and govern the Meteonians. Once you design one of them, the others are easy to draw with small variations.

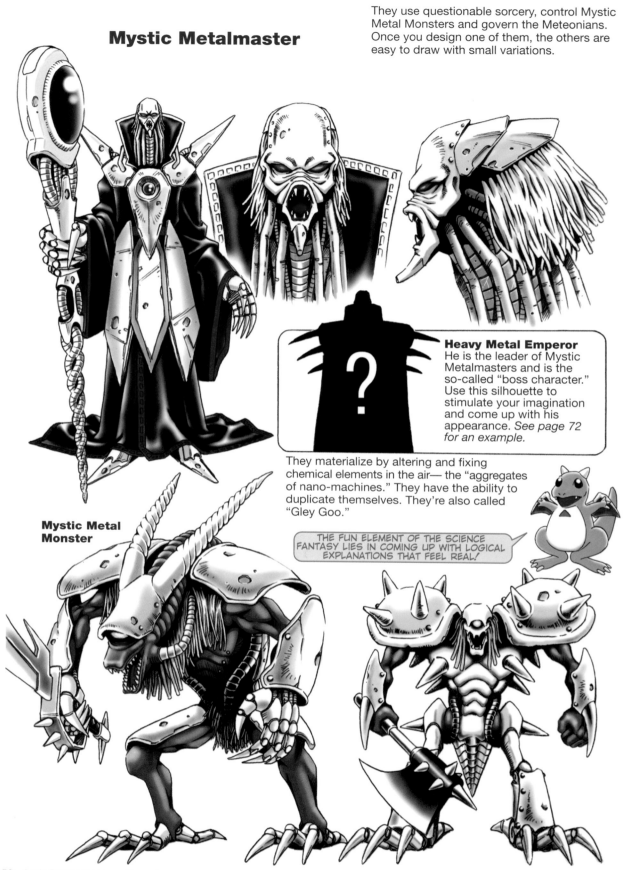

Heavy Metal Emperor
He is the leader of Mystic Metalmasters and is the so-called "boss character." Use this silhouette to stimulate your imagination and come up with his appearance. *See page 72 for an example.*

They materialize by altering and fixing chemical elements in the air— the "aggregates of nano-machines." They have the ability to duplicate themselves. They're also called "Gley Goo."

THE FUN ELEMENT OF THE SCIENCE FANTASY LIES IN COMING UP WITH LOGICAL EXPLANATIONS THAT FEEL REAL!

Mystic Metal Monster

Let's Draw a Picture Board!

A PICTURE BOARD IS AN ILLUSTRATION YOU DRAW TO SHOW THE WORLD YOU THOUGHT OF TO OTHERS!

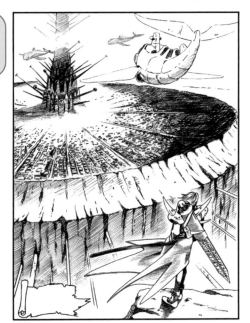

2 Once the line drawing is finished, scan it into Photoshop. Set the printing resolution to 400dpi and the scan mode to RGB Color.

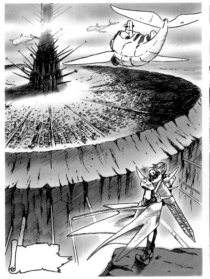

1 Decide on the composition while keeping the overall balance in mind.

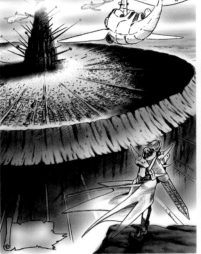

3 Create a new layer with blending set to "Multiply." When the layer is in "Multiply" mode, the line drawing is visible. You can start painting the base colors directly over the entire image.

4 Apply additional colors on the same layer. Some artists like to pile on the layers, but I (Nakajima) prefer to keep it simple.

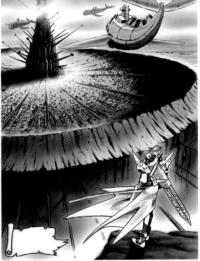

5 Color the Mobile Dick in a new layer. The procedure is the same one used in "Fire" and "Water." Once you're done coloring, any color sticking outside the lines should be removed with the eraser. Now all that's left is coloring the character.

CREATING A PICTURE BOARD IS AN IMPORTANT TASK, SINCE IT HELPS EDITORS AND ASSISTANTS UNDERSTAND WHAT IMAGE YOU WANT TO DRAW. MAKE SURE IT DOESN'T TURN OUT TOO DETAILED OR SELF-INDULGENT. WHEN YOUR COLORING IS DONE, MERGE THE LAYERS BY SELECTING "FLATTEN IMAGE" FROM THE "LAYER" MENU. *SEE THE FINISHED PICTURE ON THE NEXT PAGE!*

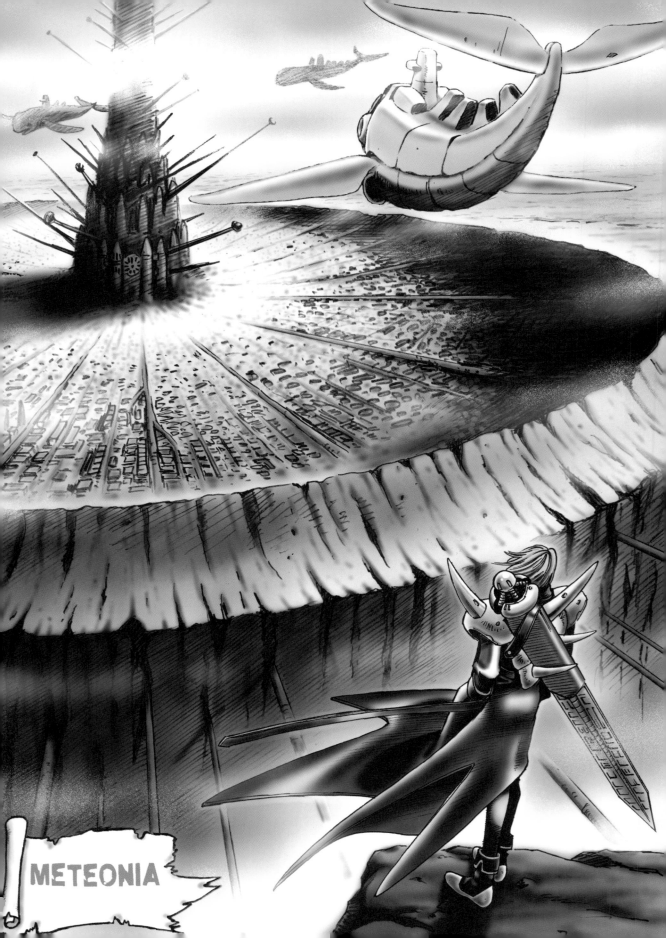

METEONIA

Creating an Asian-Style World!

Signpost to a Parallel niverse

Our heroine travels across time and space, leaving Japan (the ordinary) and arriving in a parallel universe (the extraordinary).

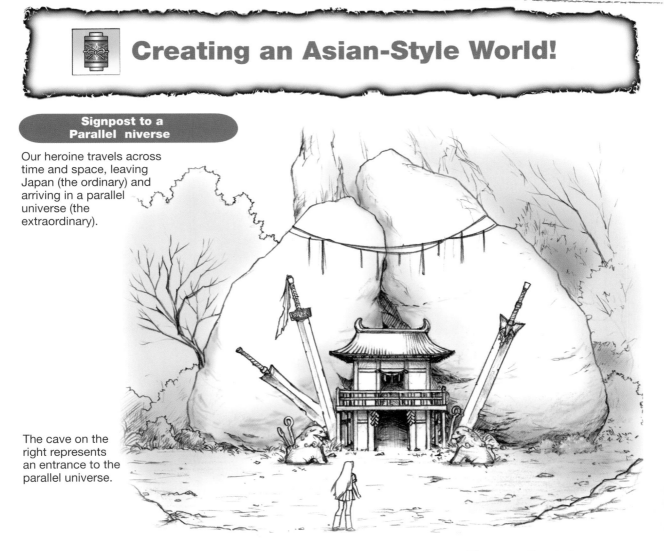

The cave on the right represents an entrance to the parallel universe.

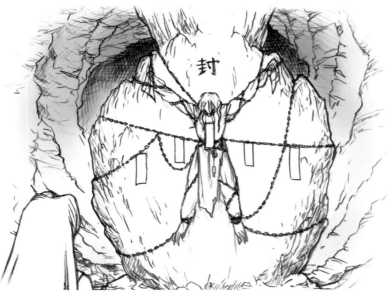

The space-time between our world and the parallel universe is connected through the cave, and anyone can come and go freely.

Our heroine (Nami), who entered the parallel universe, is sealed in on the left.

This is a concept illustration for the scene where she meets our supporting hero (Takehaya).

House— Exterior

Perspective

This technique is often used to draw a rectangular box-shaped object like the one on the left.

Vanishing point — Horizontal line (eye-level) — Vanishing point

The structure lines are intentionally left in the illustration on the left. The above shows a rough diagram.

Residents of the parallel universe are startled by the sight of these strange travelers— a half-monster and a girl.

Costumes

Costume for upper-class persons

Female Commoner

Usually, the sleeves are rolled-up. The lower half is a wraparound skirt.

Male Commoner

Sleeves are long and rolled-up. Shins are wrapped with cloth.

Dragon Palace

This is the castle where the king of the dragon race, the ruler of the sea, resides.

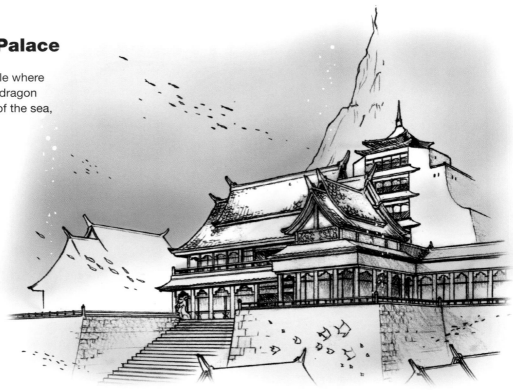

Aquatic Race

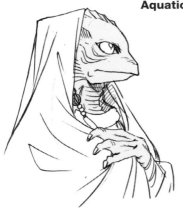

What does "Eastern" mean?

There is no internationally-accepted standard definition for the term "Eastern." For this section we've created a unique world by mixing the cultures of regions like Japan, China, the Pacific Islands, Bhutan, Nepal and India.

A large metropolis of the parallel universe

This is where the Emperor, the ruler of the humans, resides. As in medieval China, it is a walled city. Outside the city is a dangerous zone where devils roam.

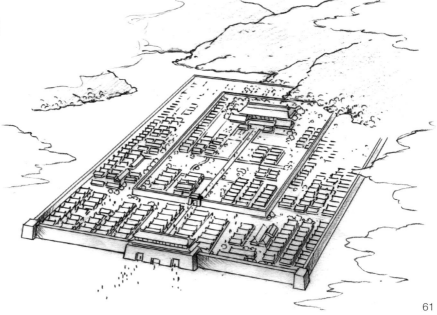

*Fushuzan

This region is located in a middle of mountain range at the northern edge of a barren continent.

The concept is a wasteland, with a constant emission of poisonous gas.

The enemy's home base is located near the summit of the mountain.

Nami and Takehaya meet by an odd trip through space. In the beginning, their goals are different; Nami just wants to return home, while Takehaya is out to rid himself of the curse that made him a half-monster and to deliver vengeance on the one who cursed him.

As they travel together, their mutual karma and the enemy's scheme are intricately woven together, and they end up saving the whole parallel universe.

Left: Takehaya sees an image of his former lover in Nami.

Let's Illustrate our Asian-Style World in Color!
Drawing Process: Watercolor

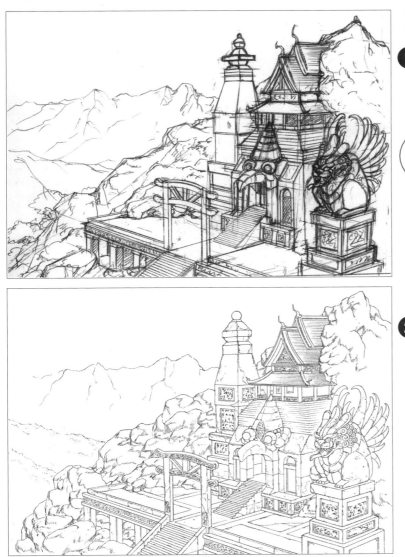

Production environment: your own room
Material used: colored ink (Dr. Martin's)

1 **DRAW A RO GH S ETCH.**
This illustration for the castle where Goko resides, near the summit of Fufusan, is put together with a Southeast Asian motif.

TRACING IS HARD ON THE EYES! REMEMBER TO TAKE FREQUENT BREAKS AS YOU TRACE THE IMAGE.

2 Using a tracing table, make a clean copy from the rough sketch. The reason you need to generate a copy is that it's easy to make mistakes the first time you color an image. When you apply color directly on paper, any mistake is fatal! But if you use a copy, you can always start over again.

Once you feel confident about coloring the piece, you can apply watercolors directly to the original draft. (But be very careful, because correction fluid is no good here!)

When color is applied to drawing paper, its surface becomes warped. If you don't like that, you can stick the drawing paper to a wooden panel with water.

Using a brush, apply plenty of water evenly across the paper.

Fit the paper on the panel by smoothing the surface and removing the air pockets.

Once it is taped with masking tape and dried, it's ready to go!

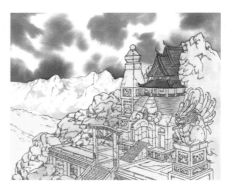

3 Color lightly over the whole image.

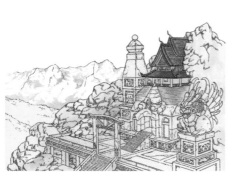

4 Color the sky. Adjusting the amount of blue blur, you can draw clouds without too much work.

5 Add shadows while keeping in mind where the light source is. Hand-painting creates a warm feel that the PC just can't achieve. Go ahead— use your imagination and give it a try!

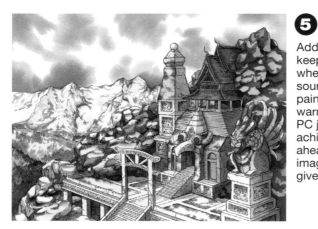

IF YOU WANT TO DRY THE WATER PAINT FAST AND SHORTEN THE COMPLETION TIME, TRY USING A HAIRDRYER.

6 **Finished!**

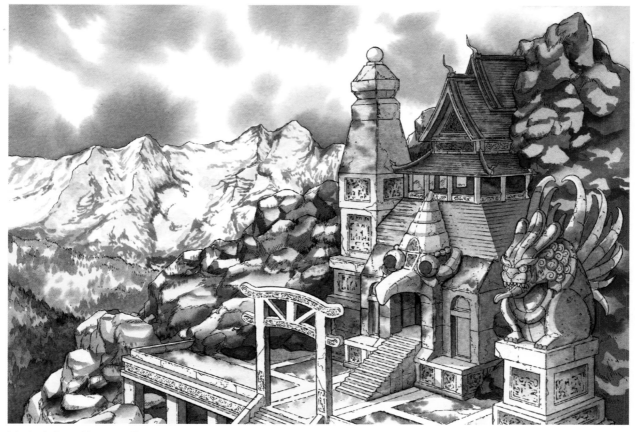

Enemy and Supporting Characters!

CHAPTER 3

Your story can't evolve without a little conflict! Appealing foes and solid supporting casts are what make a manga more exciting!

New Relationships

Let's Create Supporting Characters

Supporting characters are people close to the main characters. They have some sort of relationship with the main characters and often play important roles in the story. Let's create characters for each world who are friends as well as some who are neutral.

 ## Western Medieval Type

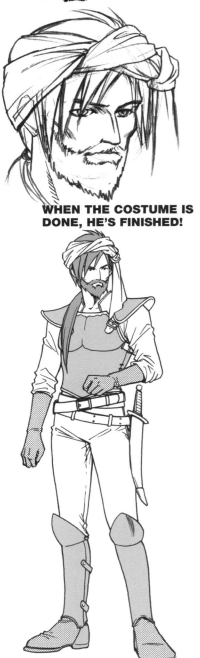

FIRST, CREATE A MALE HUMAN-BODY DOLL.

FLESH-OUT THE FIGURE.

WHEN THE COSTUME IS DONE, HE'S FINISHED!

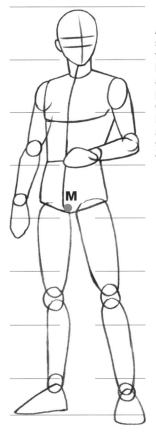

M

Approximately seven and a half to eight head-lengths is the actual human proportion. Of course, it's okay to alter it to your own taste.

The midpoint, M, represents half the body height. As the figure shows, M, for an adult, falls where the pubic bones meet.

Imagine a king of a desert nation, who hides his true identity and helps the main characters (above-right: rough sketch).

He's about thirty-two years old and a redhead. He pretends to be a bounty hunter.

Dwarves Short and bulky, they mine minerals and are good craftsmen.

Brownies Small sprites with a brownish skin tone, they measure less than one meter in height. They love helping people!

WHEN YOU DRAW A BULKY BODY TYPE, MAKE EACH SEGMENT OF THE BODY DOLL THICK AND SHORT. THE TRICK IS TO GIVE VOLUME TO THE LOWER HALF OF THE BODY.

He's holding a spool for a sewing machine.

Winged Ones They are blind prophets. Due to their powers, they've shut themselves away in a tower until a certain moment calls them forward to help the main characters.

There are only a few of her kind still left on earth.

Below: This shows how she looks when the wing is spread open.

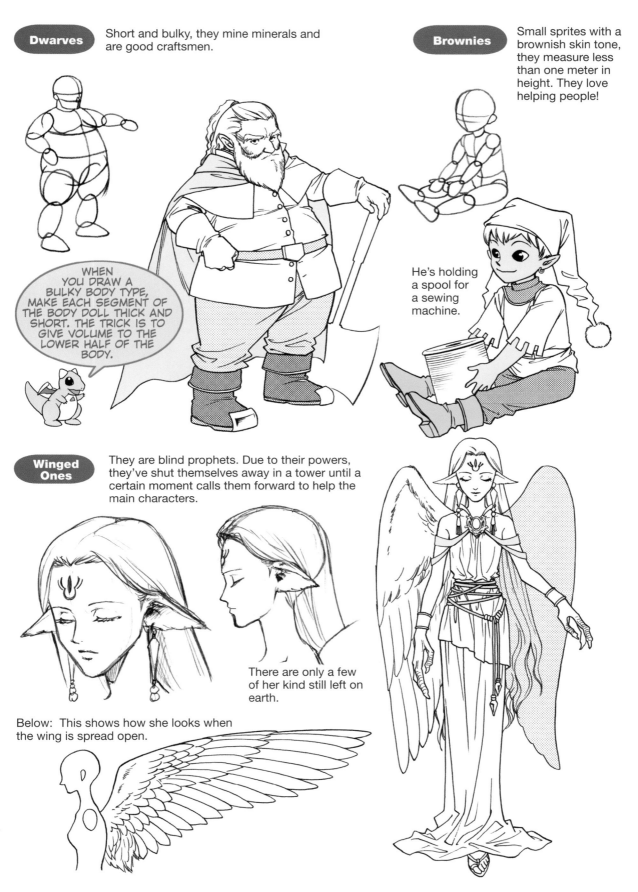

Friends of the Main Characters

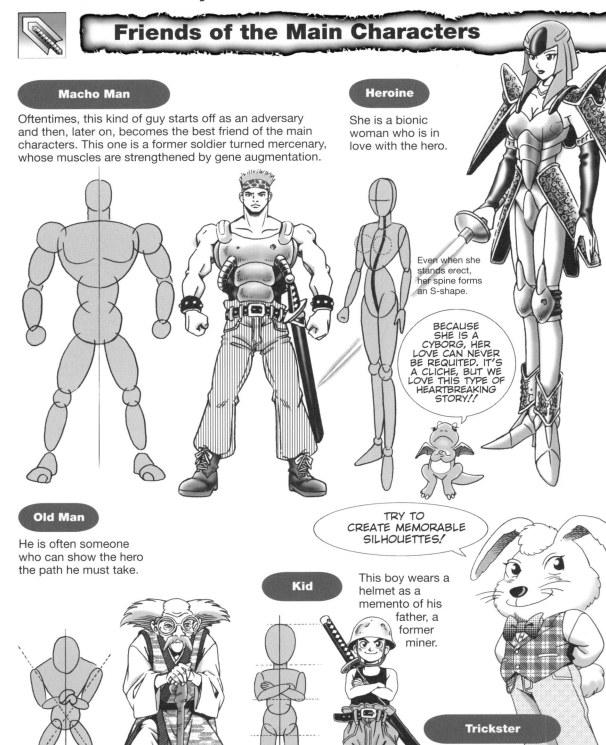

Macho Man

Oftentimes, this kind of guy starts off as an adversary and then, later on, becomes the best friend of the main characters. This one is a former soldier turned mercenary, whose muscles are strengthened by gene augmentation.

Heroine

She is a bionic woman who is in love with the hero.

Even when she stands erect, her spine forms an S-shape.

BECAUSE SHE IS A CYBORG, HER LOVE CAN NEVER BE REQUITED. IT'S A CLICHE, BUT WE LOVE THIS TYPE OF HEARTBREAKING STORY!!

Old Man

He is often someone who can show the hero the path he must take.

TRY TO CREATE MEMORABLE SILHOUETTES!

Kid

This boy wears a helmet as a memento of his father, a former miner.

Trickster

He plays an important role in furthering the plot.

Asian-Style Supporting Characters

Southern Warrior

He's a grappler and has tattoos.

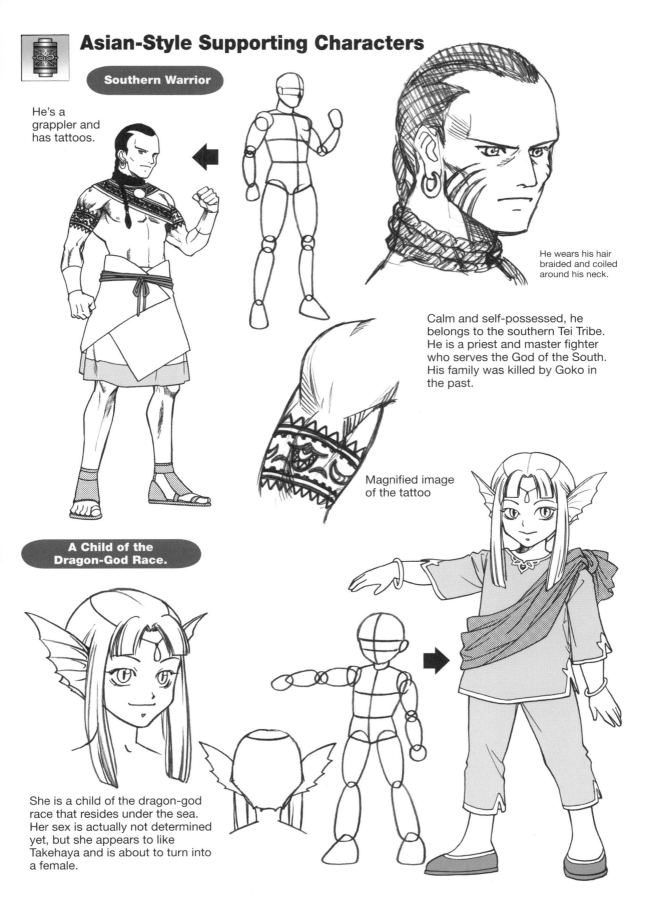

He wears his hair braided and coiled around his neck.

Calm and self-possessed, he belongs to the southern Tei Tribe. He is a priest and master fighter who serves the God of the South. His family was killed by Goko in the past.

Magnified image of the tattoo

A Child of the Dragon-God Race.

She is a child of the dragon-god race that resides under the sea. Her sex is actually not determined yet, but she appears to like Takehaya and is about to turn into a female.

Enemy Characters!

Although it ultimately depends on the context, it is generally more exciting to have forces that oppose the main characters. What makes an antagonist? The answer varies depending on personal beliefs and philosophy— but it's okay to start with something easy to understand, like a traditional war between good and evil.

In this section, let's work under the assumption that there are opposing forces in each world and create characters to confront the protagonists.

Western Medieval-Style Enemies

Human Type

Formulate an antagonist for Eric and Theodora, the Western medieval-style main characters, to defeat at the end.

He is to be a high priest of the _____ religion, who schemes to revive an ancient kingdom.

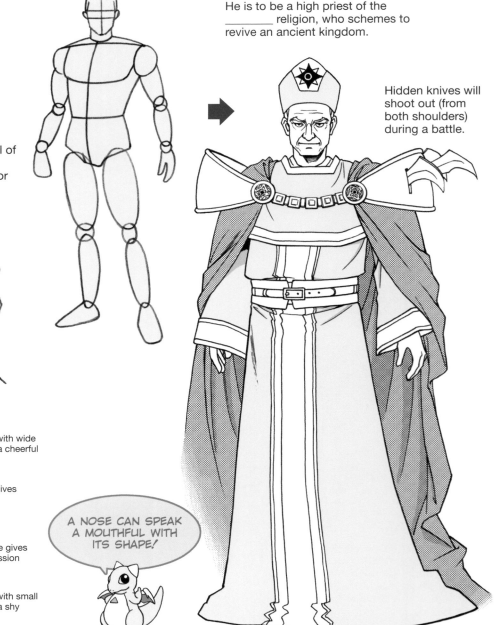

Hidden knives will shoot out (from both shoulders) during a battle.

Using a human-body doll of a middle-aged male as a base, create a concept for an ambitious man with a high social standing.

Variety of noses:

 A small nose with wide nostrils gives a cheerful impression.

 A snub nose gives an likable impression.

 A hooked nose gives a crafty impression

 A small nose with small nostrils gives a shy impression.

A NOSE CAN SPEAK A MOUTHFUL WITH ITS SHAPE!

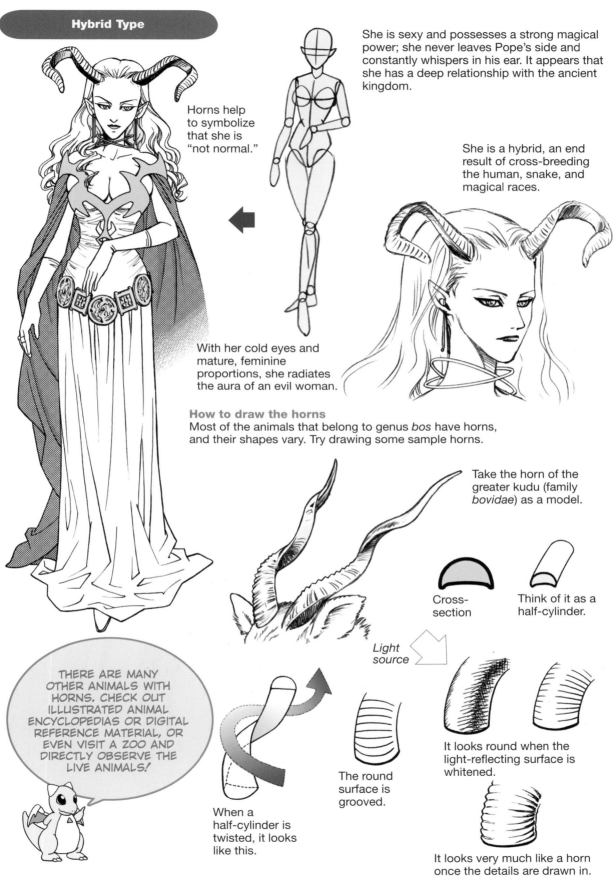

Hybrid Type

Horns help to symbolize that she is "not normal."

She is sexy and possesses a strong magical power; she never leaves Pope's side and constantly whispers in his ear. It appears that she has a deep relationship with the ancient kingdom.

She is a hybrid, an end result of cross-breeding the human, snake, and magical races.

With her cold eyes and mature, feminine proportions, she radiates the aura of an evil woman.

How to draw the horns
Most of the animals that belong to genus *bos* have horns, and their shapes vary. Try drawing some sample horns.

Take the horn of the greater kudu (family *bovidae*) as a model.

Cross-section

Think of it as a half-cylinder.

Light source

THERE ARE MANY OTHER ANIMALS WITH HORNS. CHECK OUT ILLUSTRATED ANIMAL ENCYCLOPEDIAS OR DIGITAL REFERENCE MATERIAL, OR EVEN VISIT A ZOO AND DIRECTLY OBSERVE THE LIVE ANIMALS!

When a half-cylinder is twisted, it looks like this.

The round surface is grooved.

It looks round when the light-reflecting surface is whitened.

It looks very much like a horn once the details are drawn in.

Science Fantasy Enemies

Emperor of the Heavy Metal Empire

An orthodox sample specimen.

REMEMBER THE HOMEWORK WE GAVE YOU ON PAGE *56*? WE'LL DESIGN THAT BOSS CHARACTER HERE*!!*

TRY OUT YOUR OWN DESIGN WITH THIS SILHOUETTE*!!*

Ferocious-looking eye

A RECENT TREND IN MANGA IS THAT THE EVIL BOSS CHARACTER TURNS OUT TO BE A KID. PERHAPS IT'S A REFLECTION OF MODERN SOCIETY, WITH ITS APPARENT INCREASE IN YOUTH CRIME.

Check out page 86 to see what happens when this boss turns into a monster.

Asian-Style Enemies

Human Type

A few zombie-like facial expressions . . .

This is very common.

A soldier controlled by Goko, with the Dead-User spell.

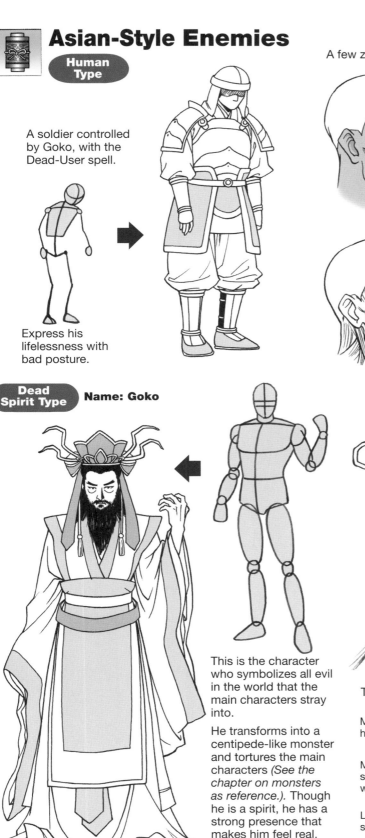

Express his lifelessness with bad posture.

This shows a standard rotting flesh look.

This is with the skin peeled off, like a dissected specimen.

Dead Spirit Type **Name: Goko**

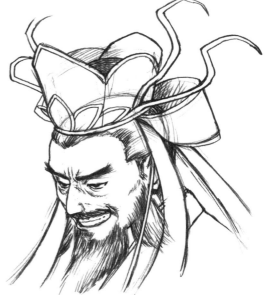

This is the character who symbolizes all evil in the world that the main characters stray into.

He transforms into a centipede-like monster and tortures the main characters *(See the chapter on monsters as reference.)*. Though he is a spirit, he has a strong presence that makes him feel real.

Techniques for an evil face:

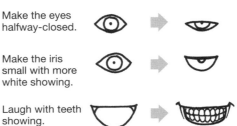

Make the eyes halfway-closed.

Make the iris small with more white showing.

Laugh with teeth showing.

A Closer Look . . .

1 Draw a female human-body doll as a base. Since she is an ajin, alter her ears and hands to give her the right look.

Make her head slightly bigger, too.

2 Draw her face, clothes, hairstyle and wings according to the rough sketch.

3 Draw in the details, then make a clean copy. Add a lot of wrinkles to show it's a soft garment.

Center line

Although the front-view image doesn't need to look completely symmetrical, it is a good idea to add a center line and to always be conscious of that line as you draw.

Her hair falls behind the wing and is not visible. However, be sure to decide what it actually looks like.

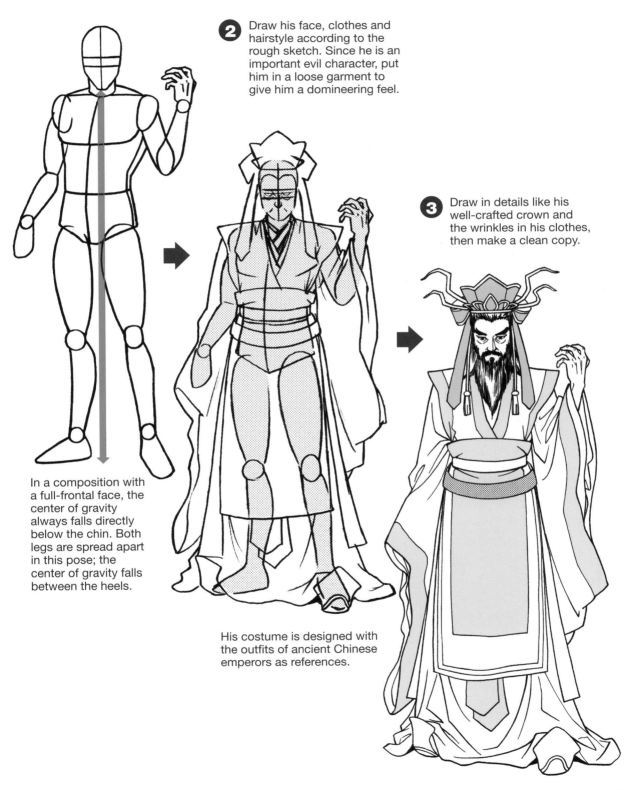

1 Draw a male human-body doll as a base. He has a stout, adult male body. His face shows the full-front view, but his body is somewhat turned.

2 Draw his face, clothes and hairstyle according to the rough sketch. Since he is an important evil character, put him in a loose garment to give him a domineering feel.

3 Draw in details like his well-crafted crown and the wrinkles in his clothes, then make a clean copy.

In a composition with a full-frontal face, the center of gravity always falls directly below the chin. Both legs are spread apart in this pose; the center of gravity falls between the heels.

His costume is designed with the outfits of ancient Chinese emperors as references.

Let's Illustrate the Enemies and Supporting Characters!

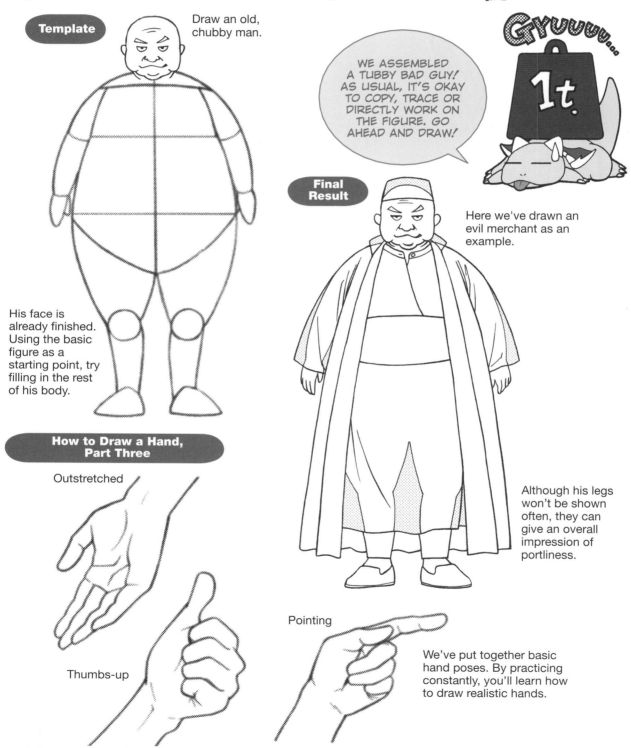

Template

Draw an old, chubby man.

WE ASSEMBLED A TUBBY BAD GUY! AS USUAL, IT'S OKAY TO COPY, TRACE OR DIRECTLY WORK ON THE FIGURE. GO AHEAD AND DRAW!

Gyuuuu...

1t.

Final Result

Here we've drawn an evil merchant as an example.

His face is already finished. Using the basic figure as a starting point, try filling in the rest of his body.

How to Draw a Hand, Part Three

Outstretched

Thumbs-up

Pointing

Although his legs won't be shown often, they can give an overall impression of portliness.

We've put together basic hand poses. By practicing constantly, you'll learn how to draw realistic hands.

Enemy and Supporting Characters!

Drawing Process:
Digital Color Illustration

① DRAW A ROUGH DRAFT.

The theme is to show that this is the middle of a journey. We'll try to express the group's solidarity.

② DIVIDE THE IMAGE.

Divide the rough draft into "character," "ship" and "background," and trace them separately for assembly later. Ink each with a pen, for scanning and layering. The printing resolution should be set at 350dpi.

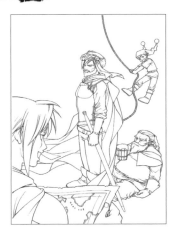

- Production Environment Software: Photoshop 7

 The hardware, printer, scanner and tablet are the same as page 19.

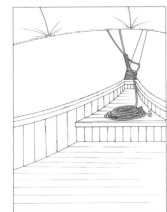

③ FILL IN THE BASE COLOR.

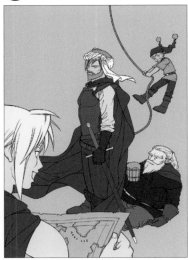

First, color the character element. Make additional layers for each character and each segment as you paint. It's hard to clean the outlines, and the best way is to use the eraser tool on the top layer. At this point, it's okay to keep it rough.

④ ADD COLORS SEPARATELY.

By locking the transparent area, only the space painted with the base color will be accessible, and any area outside will be blocked from getting painted. You can color the image efficiently using this function.

5 COMPLETE THE COLORING.

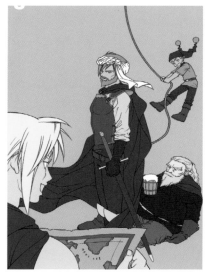

This image ended up with an unexpectedly high number of layers. If the colors are not connected side-by-side, try to group them together in the same layer.

6 ADJUST THE TONE OF THE COLOR.

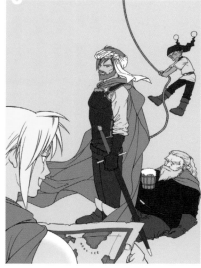

Adjust the color balance. By doing "Image"— "Adjust"— "Replace Color," or by using the color picker, clarify each detail.

7 ADD SHADOWS.

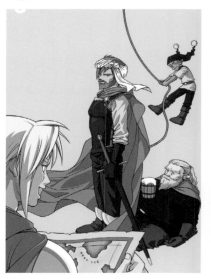

Using the "Path" tool, paint gray nets over the image with your brush set to "Multiply." Once you learn the "Path" tool, you can clean the outlines.

8 COLOR THE BACKGROUND.

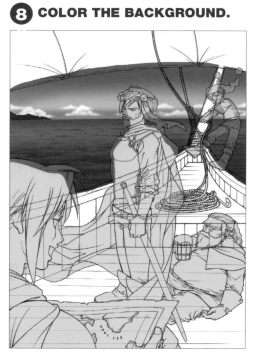

To avoid coloring unnecessary space, start this process after the line layer is stacked. Stack the layers starting with "Background" in the bottom, then "Ship" and then "Character." Start coloring the background in the bottom layer. "Character" is just there to give you a general idea, so once coloring is done, get rid of it.

9 COMBINE THE IMAGES.

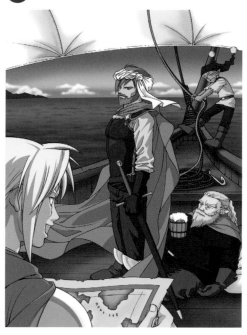

Once the background and ship are colored, copy and paste the character illustration. When it is placed properly, add finishing touches like highlights, and then combine the images. And now (on the next page) we have the finished image!

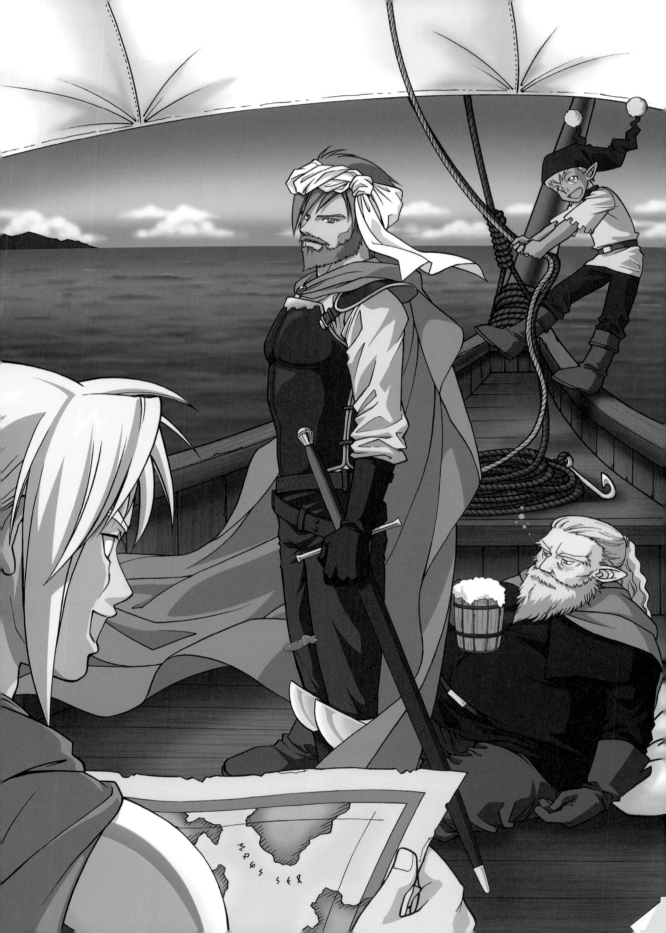

Let's Create Enemy Monsters!

Western Medieval Style

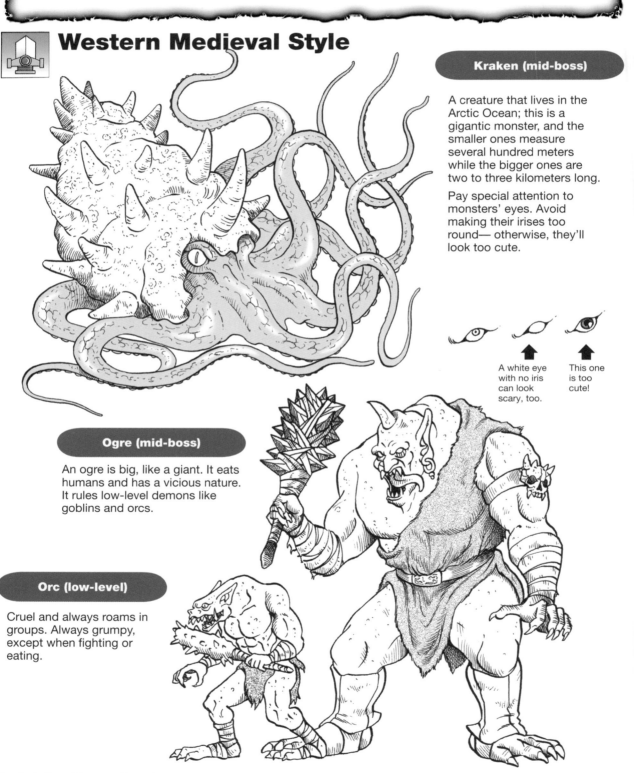

Kraken (mid-boss)

A creature that lives in the Arctic Ocean; this is a gigantic monster, and the smaller ones measure several hundred meters while the bigger ones are two to three kilometers long.

Pay special attention to monsters' eyes. Avoid making their irises too round— otherwise, they'll look too cute.

A white eye with no iris can look scary, too.

This one is too cute!

Ogre (mid-boss)

An ogre is big, like a giant. It eats humans and has a vicious nature. It rules low-level demons like goblins and orcs.

Orc (low-level)

Cruel and always roams in groups. Always grumpy, except when fighting or eating.

Griffon (mid-boss)

Has an eagle's head and wings and the body of a lion. Loves gold and often appears around gold mines.

Dragon (big boss)

An iconic fantasy monster. In the West, it almost always symbolizes evil. Its scales make superb armor, and its blood has a reputation as an elixir of life.

Fantasy monsters are beasts of the human imagination. Although often visualized in books, films and games, there can be no right or wrong depiction. So when drawing a dragon (for example), don't limit yourself to preconceived ideas. Free your mind and conceptualize the dragon that fits your world!

Sample Drawing/
Coloring Process

Western Medieval-Style Monster Edition

Production environment: your own room
Material used: colored ink & airbrush

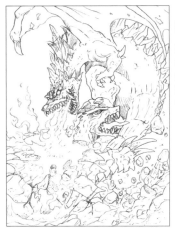

1 Draw a scene where a dragon and a turtle grapple. Depict the monsters with your own unique design.

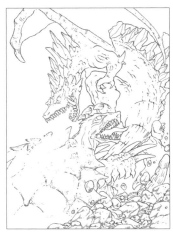

2 Ink the draft and photocopy the image onto drawing paper for coloring. Using a large brush, wet the entire image with a thin layer of water. This will make it harder for the toner to come off.

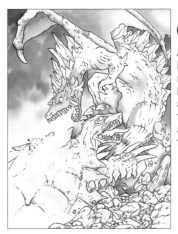

3 Apply light color to the bodies of the monsters. For the background, apply an ample amount of water, then color it as if you are adding the paint to the water.

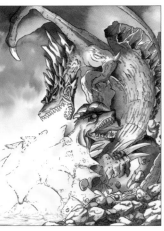

4 Since the dragon is breathing fire, use the flame as the light source and add shadows.

5 Color the flame the dragon breathes out. Express the violence of the blaze by blurring. The base color is done in yellow, with a red blur added on.

6 To make the flame look more realistic, use a brush to give it a natural flow. Study different flames in photographs and on TV.

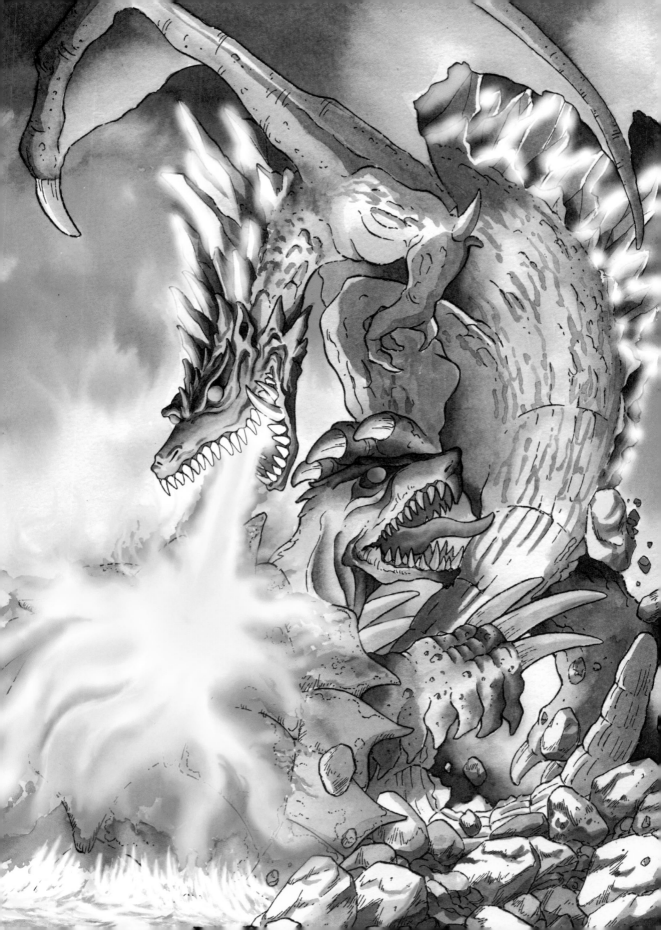

Science Fantasy

OPEN YOUR EYES AND LEARN FROM THE NATURAL WORLD AROUND US!

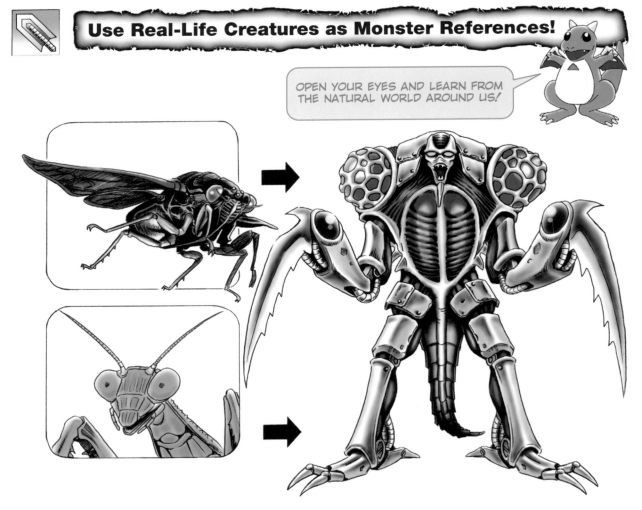

NEXT, LET'S PRACTICE HOW TO DRAW A MONSTER BY PUTTING BLOCKS TOGETHER.

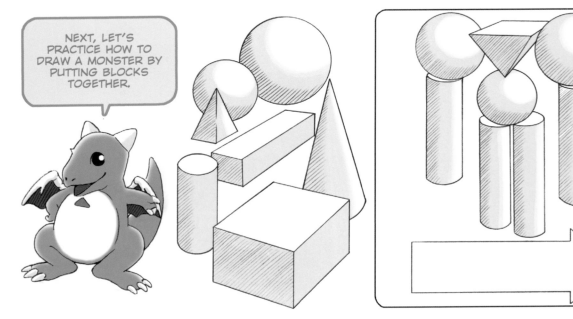

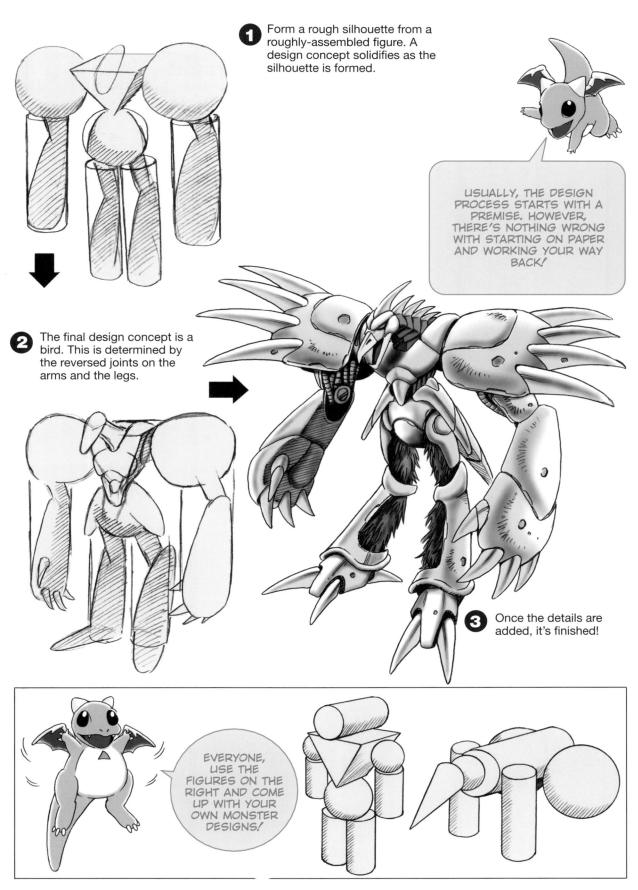

1 Form a rough silhouette from a roughly-assembled figure. A design concept solidifies as the silhouette is formed.

USUALLY, THE DESIGN PROCESS STARTS WITH A PREMISE. HOWEVER, THERE'S NOTHING WRONG WITH STARTING ON PAPER AND WORKING YOUR WAY BACK!

2 The final design concept is a bird. This is determined by the reversed joints on the arms and the legs.

3 Once the details are added, it's finished!

EVERYONE, USE THE FIGURES ON THE RIGHT AND COME UP WITH YOUR OWN MONSTER DESIGNS!

Science Fantasy

Let's Illustrate a Monster in Color!

1 This is a strong boss-character. The design premise is a mechanical devil, or Satan.

> NOW WE'LL DO A COLOR ILLUSTRATION OF THE BOSS CHARACTER FROM PAGE 72, "EMPEROR OF THE HEAVY METAL EMPIRE." IMAGINE WHAT HE'LL BECOME WHEN HE USES HIS TRANSFORMATION SPELL. *MAKOTO* IS IN CHARGE OF THIS SECTION!

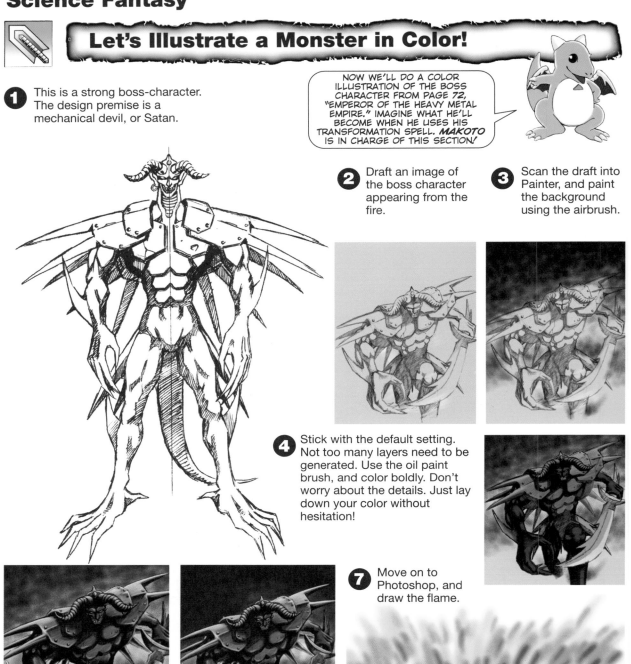

2 Draft an image of the boss character appearing from the fire.

3 Scan the draft into Painter, and paint the background using the airbrush.

4 Stick with the default setting. Not too many layers need to be generated. Use the oil paint brush, and color boldly. Don't worry about the details. Just lay down your color without hesitation!

7 Move on to Photoshop, and draw the flame.

8 Select "Blur" from the "Filter" menu in Photoshop, and blur the flame. After adding reflected flame and powder smoke to the character, the image is done.

5 Add a three-dimensional effect by using the "Impasto" brush. "Impasto" makes it look as if a thick layer of paint has been applied.

6 As the character is colored, the background starts to look too light. Let's color the background with some black paint.

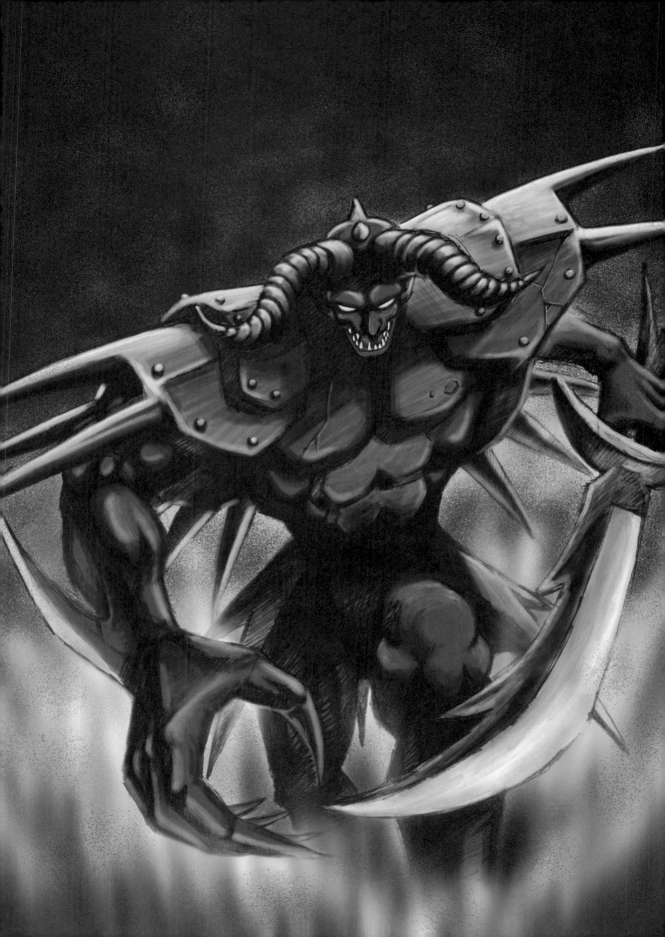

Asian-Style

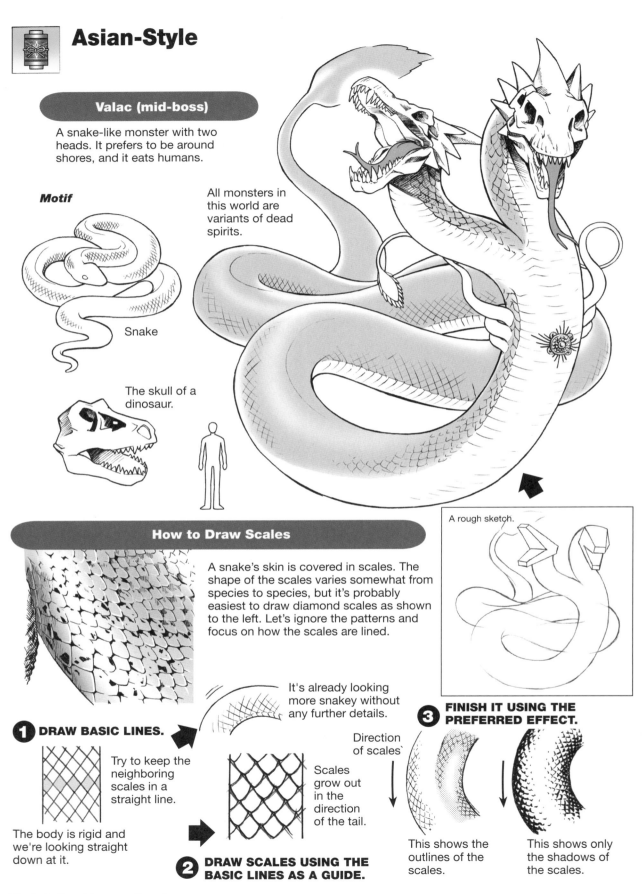

Valac (mid-boss)

A snake-like monster with two heads. It prefers to be around shores, and it eats humans.

Motif

Snake

The skull of a dinosaur.

All monsters in this world are variants of dead spirits.

A rough sketch.

How to Draw Scales

A snake's skin is covered in scales. The shape of the scales varies somewhat from species to species, but it's probably easiest to draw diamond scales as shown to the left. Let's ignore the patterns and focus on how the scales are lined.

It's already looking more snakey without any further details.

1 DRAW BASIC LINES.

Try to keep the neighboring scales in a straight line.

The body is rigid and we're looking straight down at it.

2 DRAW SCALES USING THE BASIC LINES AS A GUIDE.

Scales grow out in the direction of the tail.

Direction of scales

3 FINISH IT USING THE PREFERRED EFFECT.

This shows the outlines of the scales.

This shows only the shadows of the scales.

Final Form of Goko (Last Boss)

He turns into a centipede-like monster. Although he is a dead spirit, Goko turns into this form by combining both the poison from the Fushuzan and his grudge.

The centipede and the crab illustrated on the right are both arthropods. The bodies consist of large joints.

Motif

Centipede

Crab

Ten kinds of centipede are confirmed to exist in Japan; their large jaws carry poison. People generally think of them as eerie creatures, and that's why their qualities are incorporated into monster design.

Goko's true identity as a dead spirit is visualized and drawn into the head of the monster to make it easier to understand that he's transforming.

A rough sketch.

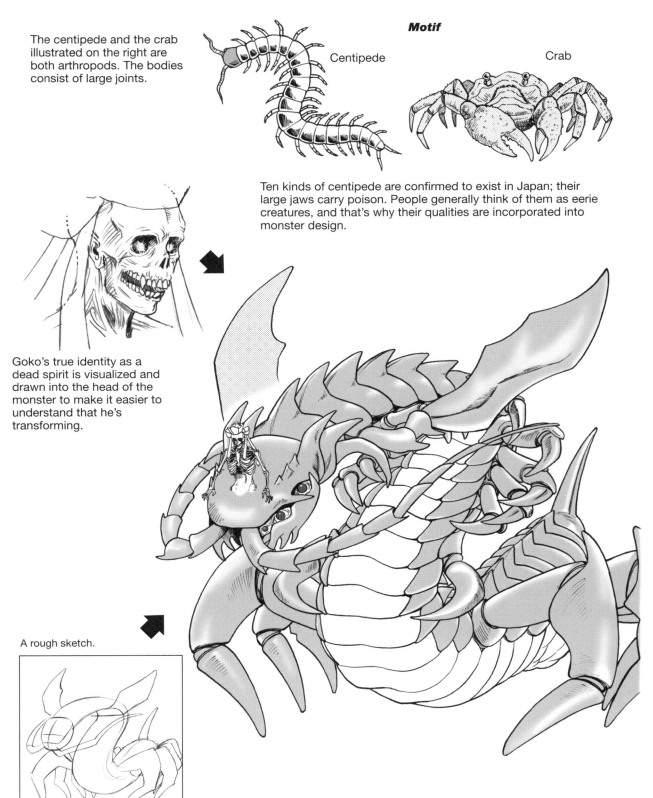

Let's Create Friendly Monsters!

Monsters aren't always enemies. Let's come up with monsters that help the main characters or become their friends, and gods that take action once the right choices are made.

Simurbh

A gigantic, eagle-like spirit bird that lives in high mountain regions. It rules over all birds and understands human speech. It serves Eluke, Holy Goddess of Ether, and will tolerate no one who might disturb the peace of the sky.

Because it lives in a cold climate, it has thick plumage.

The Simurbh is characterized by two long crests on its head and its beautiful peacock-style tailfeathers.

Its feet are covered in feathers.

Cait Sith

A walking stuffed animal . . . but not quite, huh? It is a legitimate cat fairy. It can move in the dark without letting others know its presence. It becomes attached to Theodora, and finds great pleasure in doing things for her. It usually pretends to be a regular cat. (Because of its large size, though, it doesn't fool anyone!)

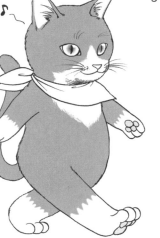

Pretending to be a cat

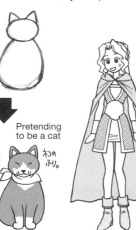

Aruru, Earth Mother Goddess

She is a mother to all the gods and gave birth to every god that descended to the earth. Her holy power is so strong that a human body cannot borrow it.

If a spellcaster is talented enough, then they can pray and borrow a degree of power to match their ability. Demons beneath the ground fear this mother goddess the most. She can probably wield her maximum strength even at the bottom of the darkest pit.

Her image is of a woman enveloped in light.

Dragons of the East do not have wings!

Sea Dragon King God

In English, the dragons of both West and East are called "dragons." Dragons of the East, however— especially those of China, Taiwan, Korea and Japan— have a very different characteristic. Unlike the Western dragon they are depicted as an incarnation of nature itself in the form of a god, and are therefore treated as a subject of religion.

This is the king of the Dragon God race, who rules the ocean. The Dragon God race usually lives under the sea in a human-like form, but at critical moments, they return to their true form and display their power. They mainly control water-related phenomena (like rain, waterspouts, and typhoons). To fight against Goko's force, the king leads his race to help the main characters.

They carry an orb and are known to control regeneration and natural phenomena.

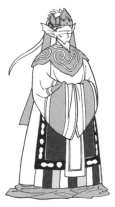

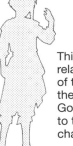

This is the relative size of the king of the Dragon God Race to the main character.

Let's Illustrate a Monster!

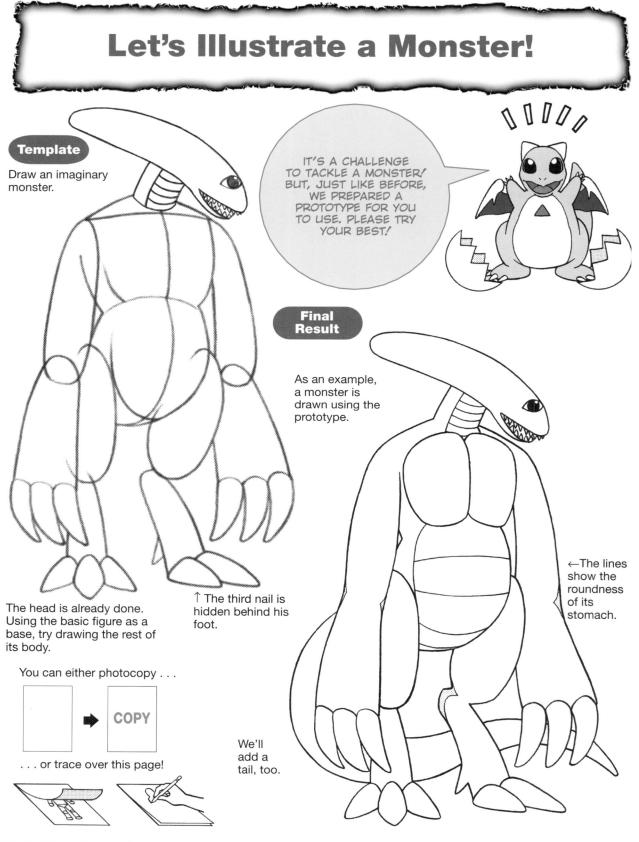

Template

Draw an imaginary monster.

IT'S A CHALLENGE TO TACKLE A MONSTER! BUT, JUST LIKE BEFORE, WE PREPARED A PROTOTYPE FOR YOU TO USE. PLEASE TRY YOUR BEST!

Final Result

As an example, a monster is drawn using the prototype.

←The lines show the roundness of its stomach.

↑ The third nail is hidden behind his foot.

The head is already done. Using the basic figure as a base, try drawing the rest of its body.

You can either photocopy . . .

COPY

. . . or trace over this page!

We'll add a tail, too.

Drawing Process: Digital Color Illustration
Western Medieval-Style Enemy Monster Edition

❶ DETERMINE THE THEME AND COMPOSITION OF THE ILLUSTRATION.

Seam

Rough Composition

Character to be used: A monster opposed to the Western medieval hero characters.

She is Ekidona, a Western medieval-style of enemy character. Imagine a scene where she reveals her true nature and launches her attack!

Theme: The composition shows the main characters confronting the huge enemy as a team.

- Production Environment Software: Photoshop 7

 The hardware, printer, scanner and tablet are the same as page 19.

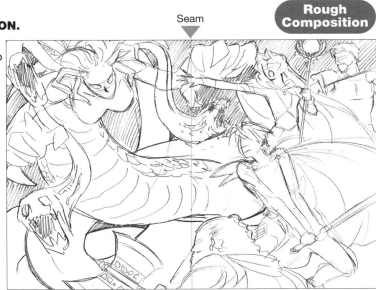

This time, we tried a horizontal layout. It is visually expansive and allows for freer composition. A two-page spread like this one is often used as an opening image for a manga series. Be mindful not to draw any critical imagery near the middle seam.

❷ SKETCH THE IMAGE.

After the drawing is Inked

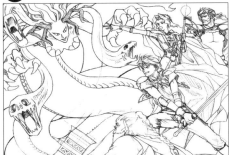

Ekidona's true form is a snake monster. She commands four snake-like monsters that come out of her head, and as she coils and twists her body, she attacks the main characters. Divide the scene into two sections, creating a contrasting composition. Place Ekidona higher while the main characters remain low, which helps to emphasize her monstrosity.

Scan the image, clean and layer the line drawing in Photoshop.

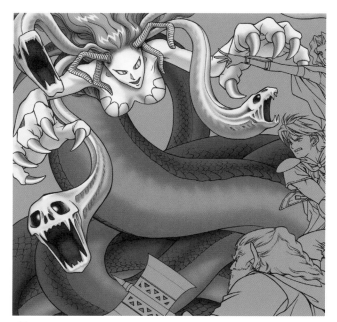

3 Because the author's PC does not have enough memory, and to avoid heavy processing, Ekidona is finished separately ahead of time. She is primarily colored using the brush tool.

4 Characters are colored in animé style. Since there are many parts to the image, try to keep unconnected colors in a single layer. This picture shows the second layer from the bottom. Even if some colors stick out (see the image), don't worry. By cleaning the outlines of each layer from the top-down, the drawing will come alive later.

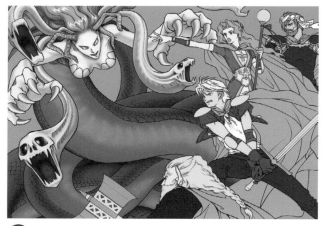

5 FINISH THE BASE COLORS.

6 ADD ALL EFFECTS OTHER THAN THE SHADOWS.

7 ADD SHADOWS!

To avoid darkening the image, don't use gray for the characters' skin. Instead, use deeper variations of the skin's base color in the shadows. To add the rest of the shadows, go to "Image"— "Adjust"— "Selective Color." Create shadow colors by changing the black value (the bottom slider). By upping the value by 20% to 30%, you can generate colors that are just as dark as adding gray through "multiply." Once the shadows are in place, merge the colored layers, touch it up with highlights, combine the background and the image— and we have the finished image!

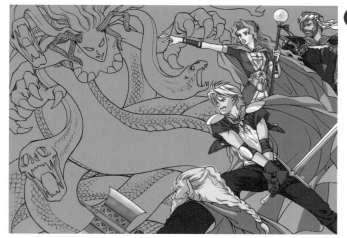

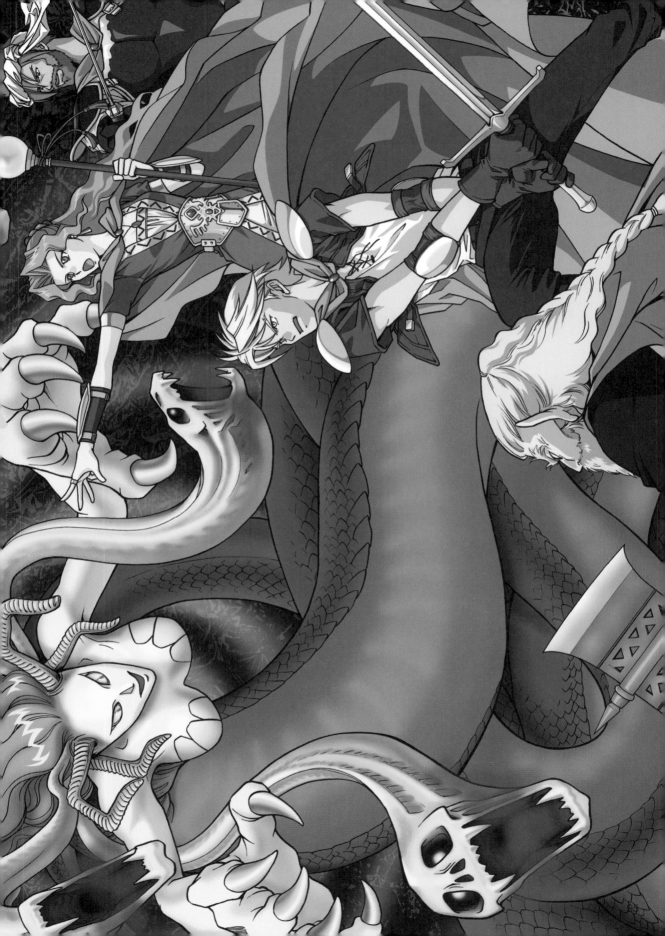

Fantasy Variations

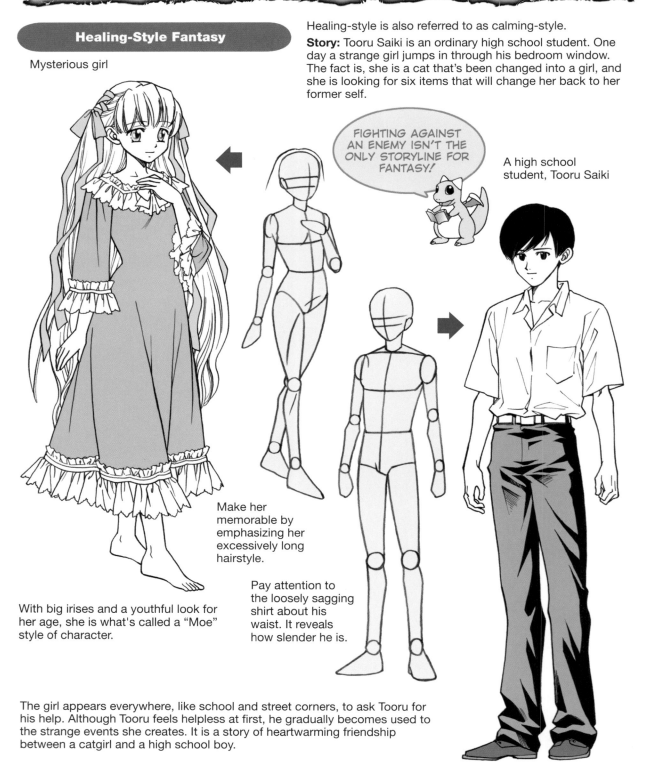

Healing-Style Fantasy

Mysterious girl

Healing-style is also referred to as calming-style.

Story: Tooru Saiki is an ordinary high school student. One day a strange girl jumps in through his bedroom window. The fact is, she is a cat that's been changed into a girl, and she is looking for six items that will change her back to her former self.

FIGHTING AGAINST AN ENEMY ISN'T THE ONLY STORYLINE FOR FANTASY!

A high school student, Tooru Saiki

Make her memorable by emphasizing her excessively long hairstyle.

With big irises and a youthful look for her age, she is what's called a "Moe" style of character.

Pay attention to the loosely sagging shirt about his waist. It reveals how slender he is.

The girl appears everywhere, like school and street corners, to ask Tooru for his help. Although Tooru feels helpless at first, he gradually becomes used to the strange events she creates. It is a story of heartwarming friendship between a catgirl and a high school boy.

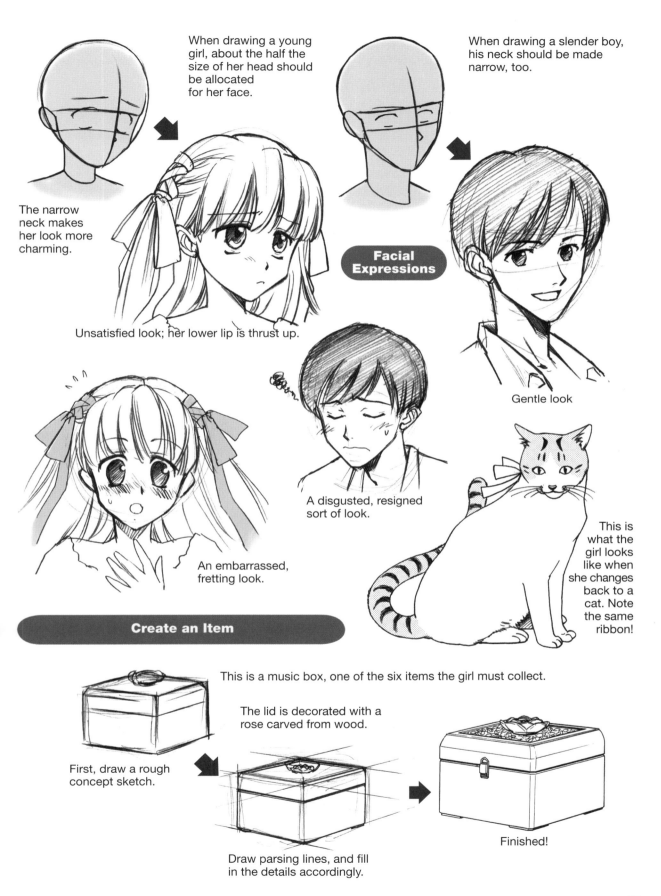

When drawing a young girl, about the half the size of her head should be allocated for her face.

When drawing a slender boy, his neck should be made narrow, too.

The narrow neck makes her look more charming.

Facial Expressions

Unsatisfied look; her lower lip is thrust up.

Gentle look

An embarrassed, fretting look.

A disgusted, resigned sort of look.

This is what the girl looks like when she changes back to a cat. Note the same ribbon!

Create an Item

This is a music box, one of the six items the girl must collect.

The lid is decorated with a rose carved from wood.

First, draw a rough concept sketch.

Draw parsing lines, and fill in the details accordingly.

Finished!

Drawing Process: Black & White Illustration

1 **DETERMINE THE THEME AND COMPOSITION OF THE ILLUSTRATION.**

Use the characters from pages 96 and 97.

Theme: Gentleness and Mischief.
First, draw several rough drafts. (A) is the first draft because the story is only beginning to form. (B) is a rough draft after several attempts. By adding the ornamental frame and manga-like cat, the fantasy element is brought out.

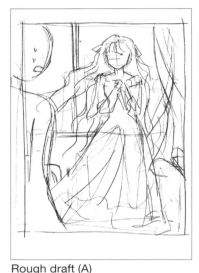

Rough draft (A)

Rough draft (B)

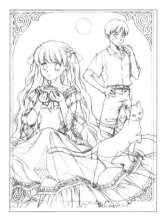

2 **SKETCH THE IMAGE.**

Select the rough draft (B) for now. Create details like ornamentation without losing the overall balance. At this point, imagine the finished version in your mind as you work.

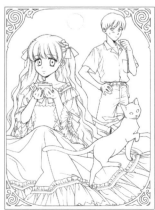

3 **INK THE DRAFT WITH PEN AND USE THE ERASER TO CLEAN UP.**

4 **ADD TONE!**

Add tone to the background too, and finish with white. *(See the next page.)*

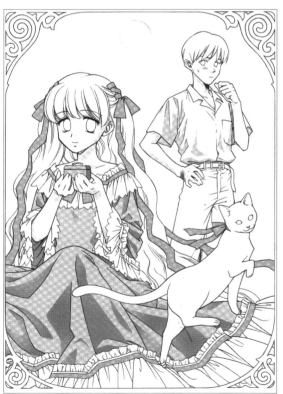

There is a finished color illustration on page 100.

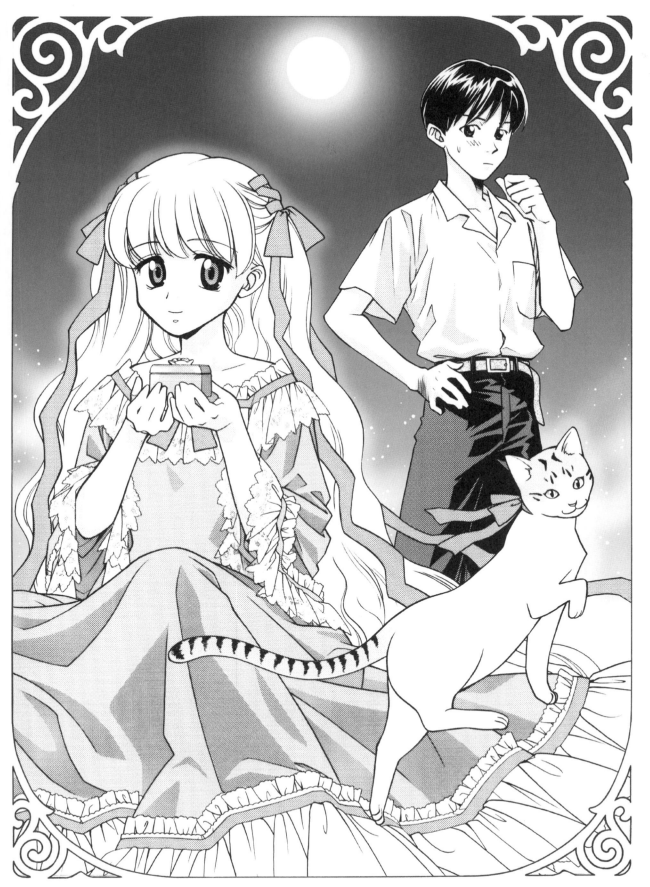

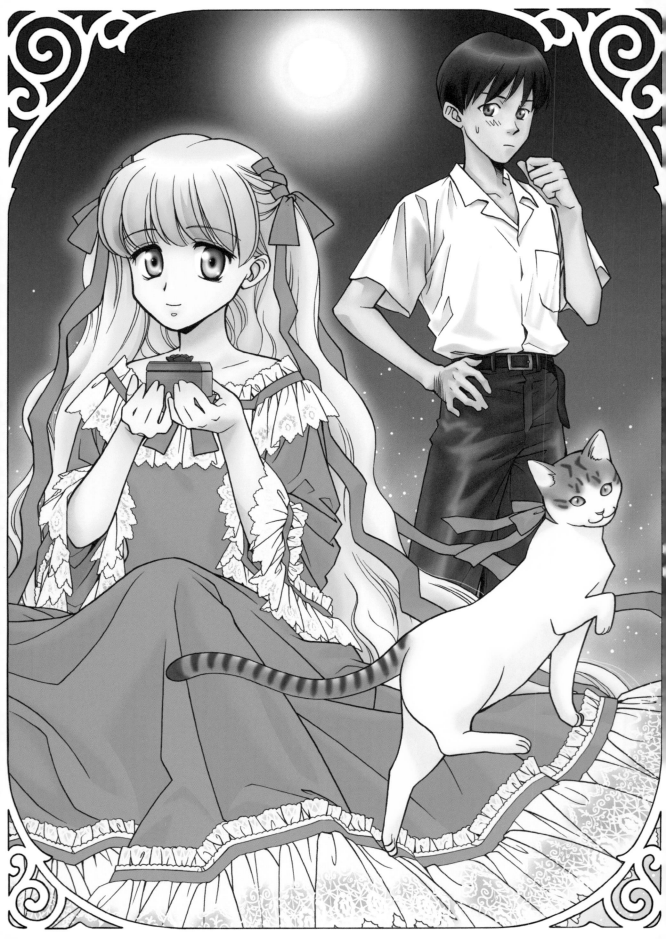

Magic and Equipment!

CHAPTER 4

Let's create props for our characters
to fit with the world you've created!

Accessories

In this chapter, the main theme is divided into *items* and *magic* (or *magic-like effects*); these will be further categorized by type. Icons included in this section match the themes for the three worlds we've introduced so far. Please look at them along with the characters and worlds from previous chapters!

Let's Plan our Magic and Equipment by Category!

Before we introduce original items for each world, let's look at representative items that often appear in general works of fantasy.

Please note, these illustrations represent only basic forms. It's up to the imagination of manga artists to add a unique feel to them!

Weapons • Armor These are items for self-defense or for attack.

Armor

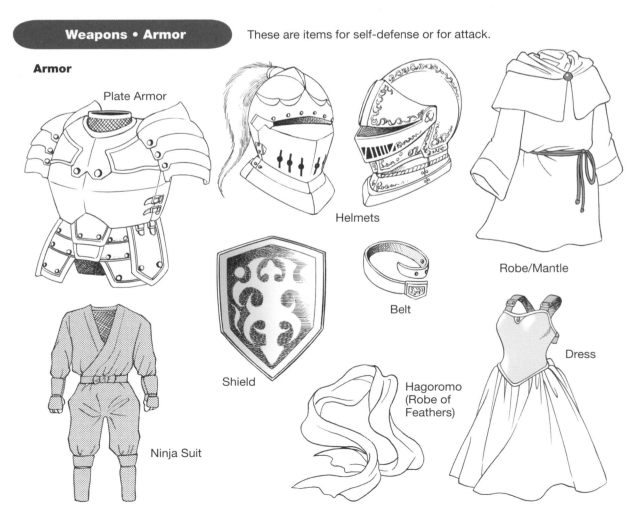

Plate Armor

Helmets

Robe/Mantle

Shield

Belt

Dress

Ninja Suit

Hagoromo
(Robe of
Feathers)

Weapons

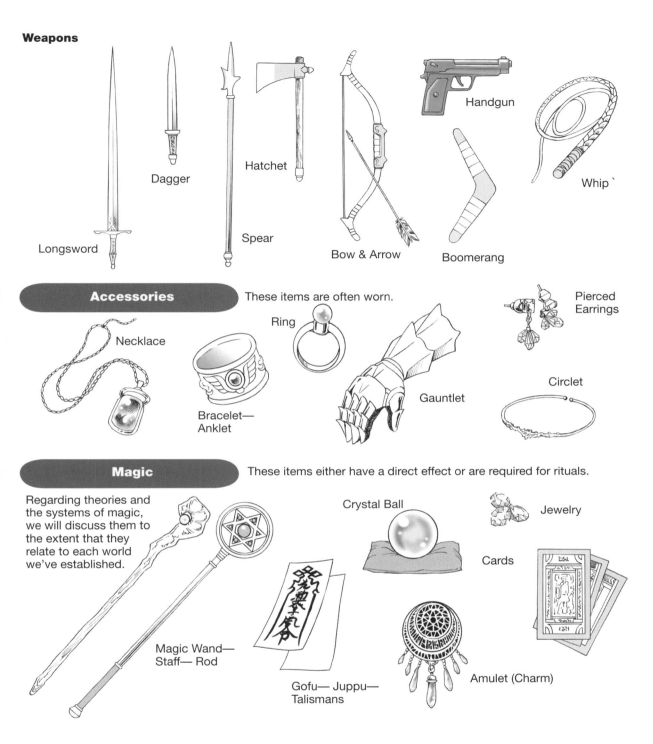

Handgun

Dagger

Hatchet

Whip `

Spear

Longsword

Bow & Arrow

Boomerang

Accessories

These items are often worn.

Ring

Pierced Earrings

Necklace

Gauntlet

Circlet

Bracelet— Anklet

Magic

These items either have a direct effect or are required for rituals.

Regarding theories and the systems of magic, we will discuss them to the extent that they relate to each world we've established.

Crystal Ball

Jewelry

Cards

Magic Wand— Staff— Rod

Gofu— Juppu— Talismans

Amulet (Charm)

Let's investigate some of the above items and further develop their designs to suit each world we've established!

1. Weapons & Armor

GO! to page 104

2. Magic and Magical Equipment

GO! to page 113

1. Weapons & Armor

Let's Design Western Medieval Fantasy Costumes!

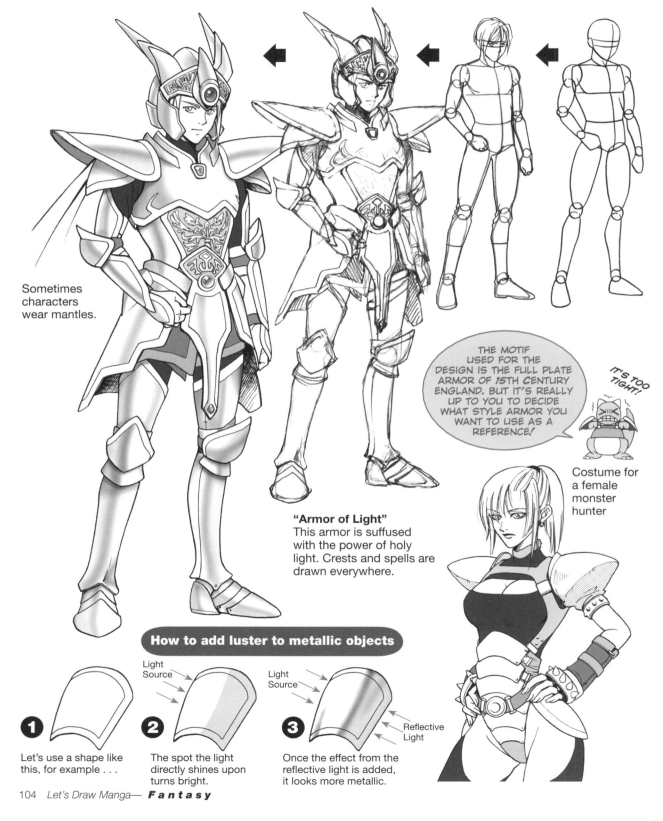

Sometimes characters wear mantles.

"Armor of Light"
This armor is suffused with the power of holy light. Crests and spells are drawn everywhere.

THE MOTIF USED FOR THE DESIGN IS THE FULL PLATE ARMOR OF 15TH CENTURY ENGLAND. BUT IT'S REALLY UP TO YOU TO DECIDE WHAT STYLE ARMOR YOU WANT TO USE AS A REFERENCE!

IT'S TOO TIGHT!

Costume for a female monster hunter

How to add luster to metallic objects

1
Let's use a shape like this, for example . . .

2
Light Source
The spot the light directly shines upon turns bright.

3
Light Source
Reflective Light
Once the effect from the reflective light is added, it looks more metallic.

1. Weapons & Armor

Let's Design Science Fantasy Costumes!

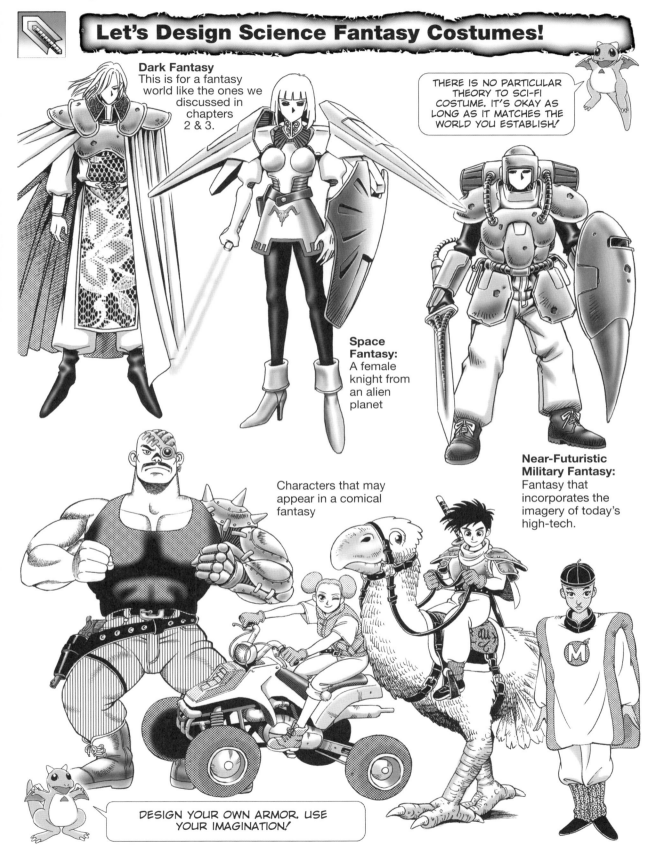

Dark Fantasy
This is for a fantasy world like the ones we discussed in chapters 2 & 3.

THERE IS NO PARTICULAR THEORY TO SCI-FI COSTUME. IT'S OKAY AS LONG AS IT MATCHES THE WORLD YOU ESTABLISH!

Space Fantasy:
A female knight from an alien planet

Near-Futuristic Military Fantasy:
Fantasy that incorporates the imagery of today's high-tech.

Characters that may appear in a comical fantasy

DESIGN YOUR OWN ARMOR. USE YOUR IMAGINATION!

1. Weapons & Armor

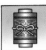

Let's Design Asian Fantasy Costumes!

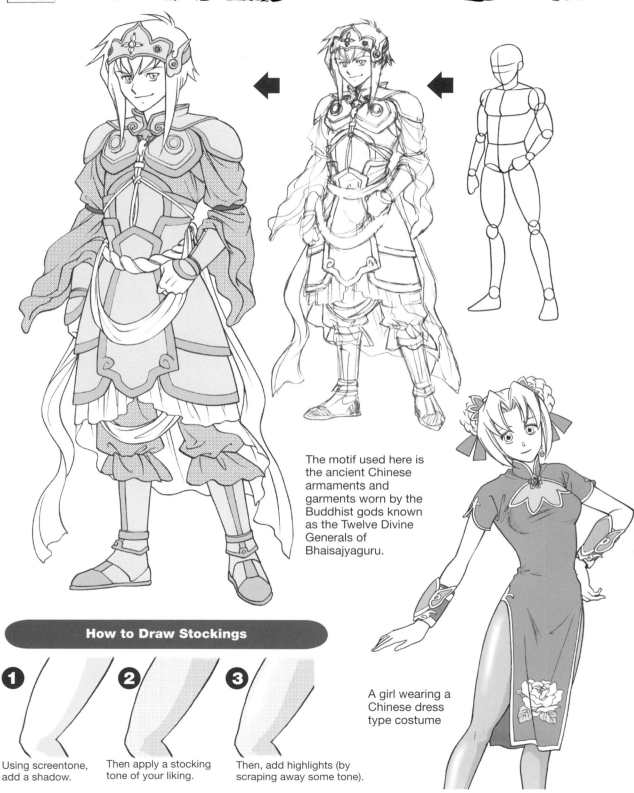

The motif used here is the ancient Chinese armaments and garments worn by the Buddhist gods known as the Twelve Divine Generals of Bhaisajyaguru.

How to Draw Stockings

1 Using screentone, add a shadow.

2 Then apply a stocking tone of your liking.

3 Then, add highlights (by scraping away some tone).

A girl wearing a Chinese dress type costume

1. Weapons & Armor

Let's Design Western Medieval Weapons!

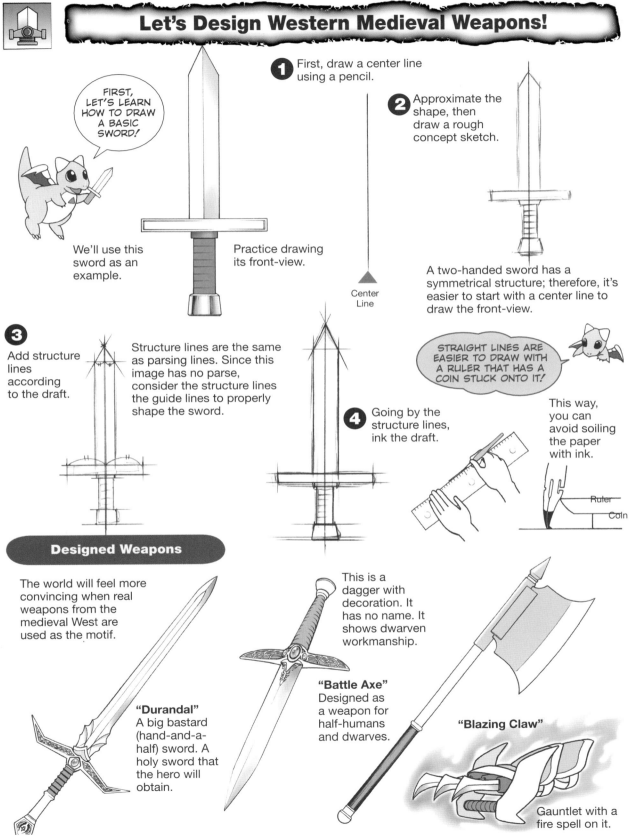

FIRST, LET'S LEARN HOW TO DRAW A BASIC SWORD!

We'll use this sword as an example.

Practice drawing its front-view.

1 First, draw a center line using a pencil.

Center Line

2 Approximate the shape, then draw a rough concept sketch.

A two-handed sword has a symmetrical structure; therefore, it's easier to start with a center line to draw the front-view.

3 Add structure lines according to the draft.

Structure lines are the same as parsing lines. Since this image has no parse, consider the structure lines the guide lines to properly shape the sword.

4 Going by the structure lines, ink the draft.

STRAIGHT LINES ARE EASIER TO DRAW WITH A RULER THAT HAS A COIN STUCK ONTO IT!

This way, you can avoid soiling the paper with ink.

Ruler

Coin

Designed Weapons

The world will feel more convincing when real weapons from the medieval West are used as the motif.

"Durandal"
A big bastard (hand-and-a-half) sword. A holy sword that the hero will obtain.

This is a dagger with decoration. It has no name. It shows dwarven workmanship.

"Battle Axe"
Designed as a weapon for half-humans and dwarves.

"Blazing Claw"

Gauntlet with a fire spell on it.

1. Weapons & Armor

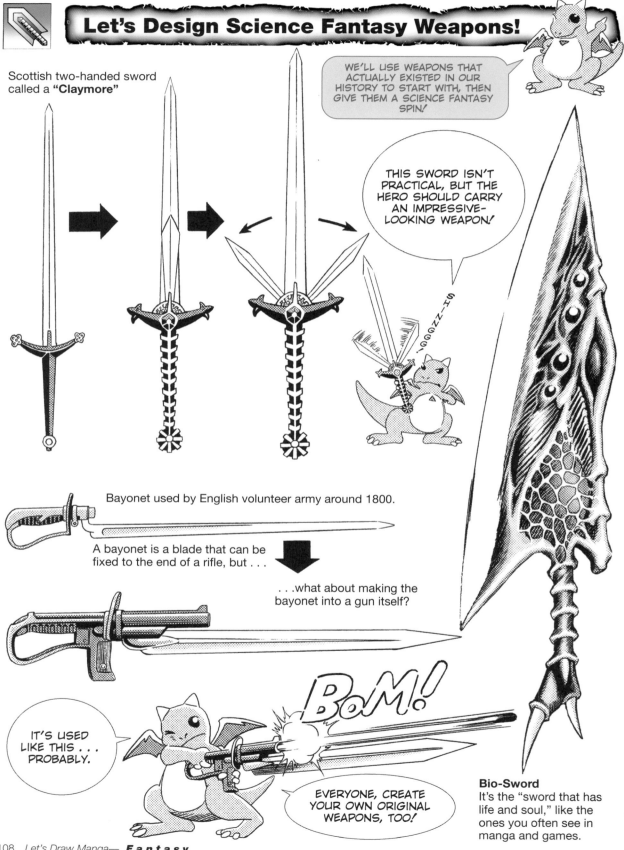

Let's Design Science Fantasy Weapons!

Scottish two-handed sword called a **"Claymore"**

WE'LL USE WEAPONS THAT ACTUALLY EXISTED IN OUR HISTORY TO START WITH, THEN GIVE THEM A SCIENCE FANTASY SPIN!

THIS SWORD ISN'T PRACTICAL, BUT THE HERO SHOULD CARRY AN IMPRESSIVE-LOOKING WEAPON!

SHI-ZZZGGG!

Bayonet used by English volunteer army around 1800.

A bayonet is a blade that can be fixed to the end of a rifle, but . . .

. . .what about making the bayonet into a gun itself?

BoM!

IT'S USED LIKE THIS . . . PROBABLY.

EVERYONE, CREATE YOUR OWN ORIGINAL WEAPONS, TOO!

Bio-Sword
It's the "sword that has life and soul," like the ones you often see in manga and games.

1. Weapons & Armor

Let's Design Asian Fantasy Weapons!

First, Decide on a Weapon Model.

WE'LL CHOOSE A BOW AND ARROW FOR THE GIRL'S WEAPON.

This is a standard shape for a bow. Using this as a template, let's design an original bow.

Curves are hard to draw. In a case like this, use a French curve, and draw the curves with its help. Look for a French curve that meets your requirements at an art store!

Designing

Since it's an Eastern-style world, add patterns that reflect the environment.

Magnified image

The same pattern is drawn on the flipped side.

Magnified image

Again, the same pattern is drawn on the flipped side.

Finished!

Sample

This balances well when the chin and the heel are lined up.

Line up the direction of the eye and the direction of the arrow.

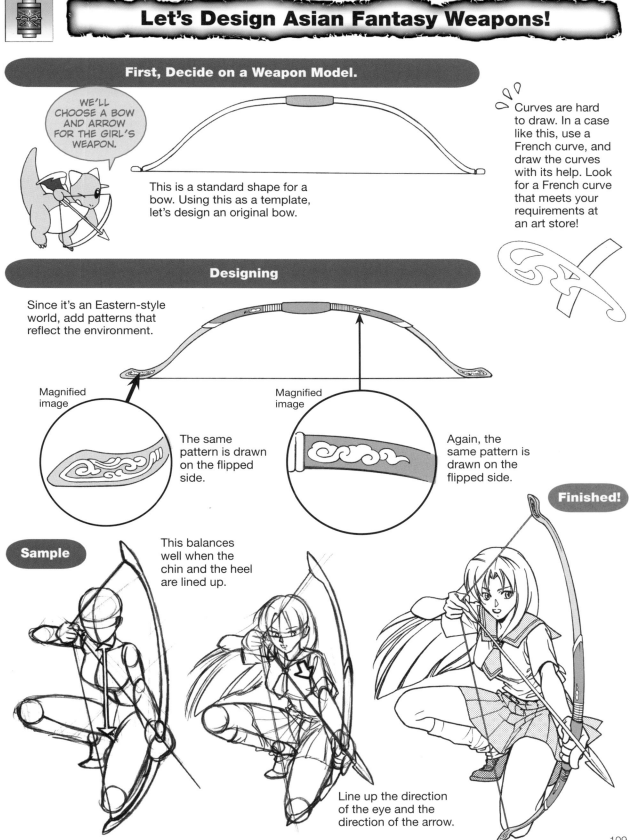

1. Weapons & Armor

Let's Design Western Medieval Accessories!

It may be a simple ornament, or it may have a magical effect just by wearing it, or it may have some historical significance. It's easy to generate ideas for items that fit with your story!

> IT'S TRUE MANY DESIGNS ARE MADE TO DECORATE FEMALE COSTUMES, BUT IT'S ALSO FUN TO COME UP WITH SOMETHING FOR MEN!

Start with a Basic Bracelet.

For example, draw this bracelet with a slight high-angle perspective.

Center Line

1 FIRST, DRAW THE CENTER LINE.

2 APPROXIMATE THE SHAPE AND DRAW AN IMAGE SKETCH.

So far, this is the same procedure used in drawing a sword.

Template

It's like drawing a cylinder.

3 USING THE OVAL TEMPLATE AND KEEPING THE CENTER LINE IN MIND, ADD STRUCTURE LINES.

4 RELYING ON THE STRUCTURE LINES, INK THE DRAFT WITH PEN.

Show its thickness.

When making a clean copy using a template, use its edge against the drawing pen like this.

* Spoon pen not recommended.

Designed Accessories

"Mysterious Bracelet"

It has a holy power, and just by wearing it, it enhances the wearer's capacity to heal.

"Aruru's Pendant"

Only the powerful priests/priestesses are allowed to wear it.

"Magic Circlet"

It has a calming effect and helps to increase magical power.

> PAY DETAILED ATTENTION TO SMALL PROPS, TOO!! IT ONLY HELPS TO ENHANCE THE QUALITY OF YOUR WORK!

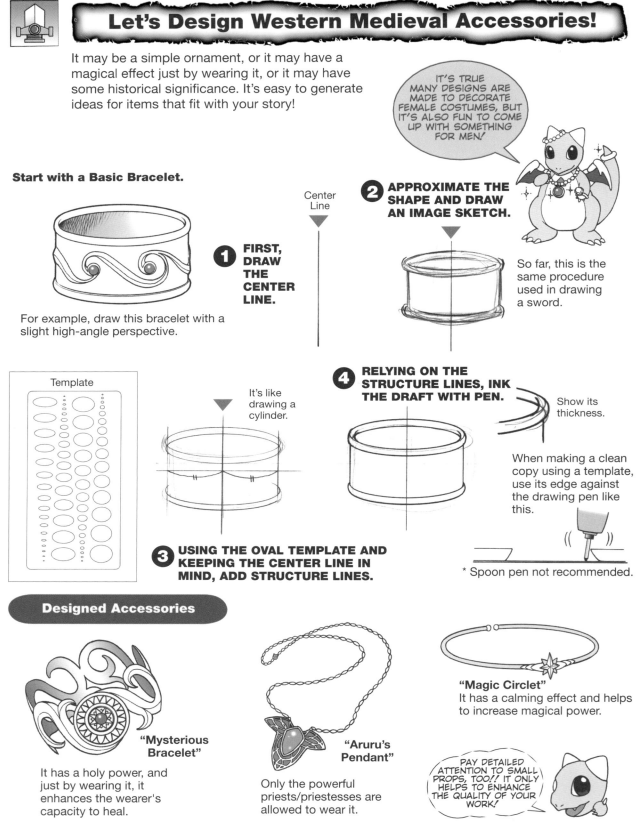

1. Weapons & Armor

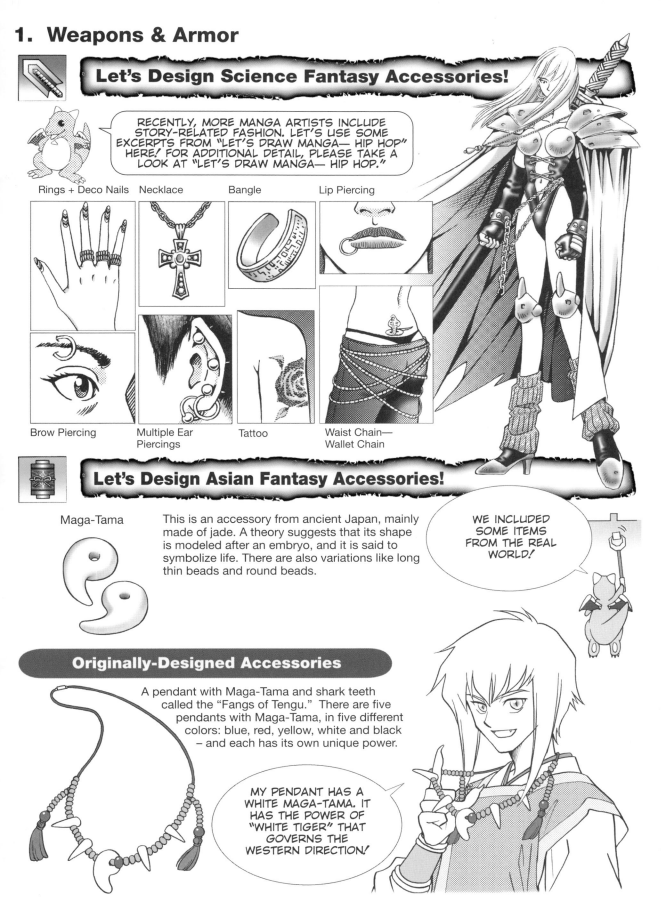

Let's Design Science Fantasy Accessories!

RECENTLY, MORE MANGA ARTISTS INCLUDE STORY-RELATED FASHION. LET'S USE SOME EXCERPTS FROM "LET'S DRAW MANGA— HIP HOP" HERE! FOR ADDITIONAL DETAIL, PLEASE TAKE A LOOK AT "LET'S DRAW MANGA— HIP HOP."

Rings + Deco Nails

Necklace

Bangle

Lip Piercing

Brow Piercing

Multiple Ear Piercings

Tattoo

Waist Chain— Wallet Chain

Let's Design Asian Fantasy Accessories!

Maga-Tama

This is an accessory from ancient Japan, mainly made of jade. A theory suggests that its shape is modeled after an embryo, and it is said to symbolize life. There are also variations like long thin beads and round beads.

WE INCLUDED SOME ITEMS FROM THE REAL WORLD!

Originally-Designed Accessories

A pendant with Maga-Tama and shark teeth called the "Fangs of Tengu." There are five pendants with Maga-Tama, in five different colors: blue, red, yellow, white and black – and each has its own unique power.

MY PENDANT HAS A WHITE MAGA-TAMA. IT HAS THE POWER OF "WHITE TIGER" THAT GOVERNS THE WESTERN DIRECTION!

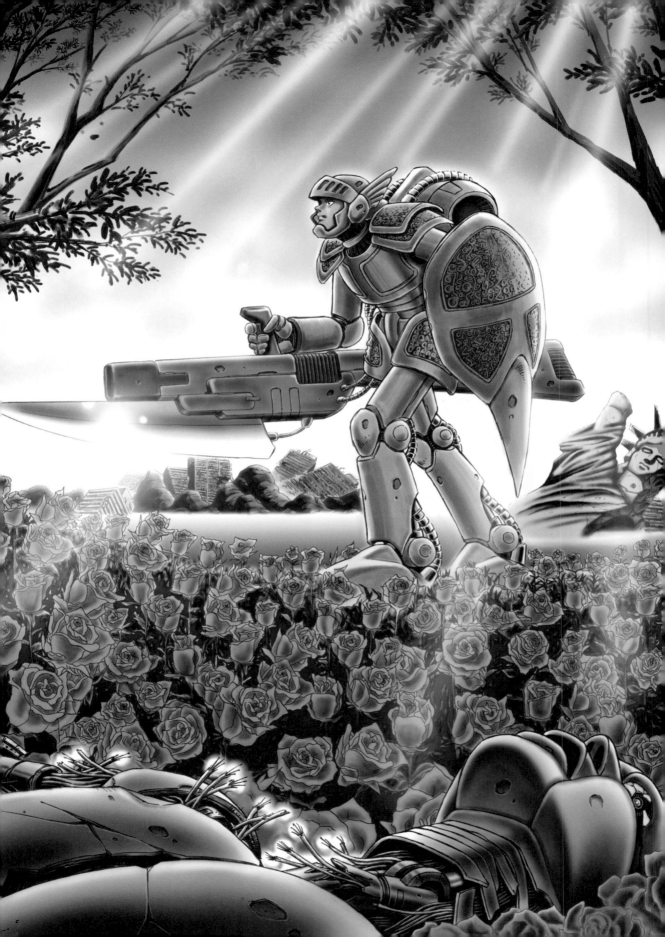

2. Magic and Magical Equipment

Magic in Western Medieval Fantasy

Offensive Magic

WE HAVE TO HAVE MAGIC IN FANTASY MANGA! ALTHOUGH MAGIC IS GETTING MORE AND MORE COMPLICATED, IT CAN BE ROUGHLY DIVIDED INTO THESE TYPES.

This type of magic requires negotiation or contract with supernatural entities called "elemental spirits" (like fire and water), "natural spirits" (like trees and flowers), or gods. It requires specialized equipment for rituals, and for the caster to be temporarily possessed by some divine spirit. Mostly, this type of magic brings about miracles after the chanting of a spell.

A sample spell . . .

Source of All Powers:

Bring forth the breath of the water ruler!

Come now!

Turn to torrent!

Wash away all!

Composing the spell like a classic poem will make it sound more convincing. You can also create your own letters by altering the ancient alphabet.

Healing Magic

Often performed by clerics and alchemists.

A sample spell . . .

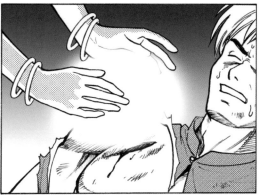

Healing injuries (like this one), curing illness, detoxifying, reviving and so forth. Lifting curses might also fall under this category.

Item

"Magic Wand"

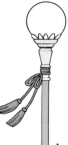

As everyone knows, this is the armament of witches and wizards. This particular variation has a large, yellow crystal ball on it.

Many magicians tote this sort of tool around.

Defensive Magic

"Magic Circles" like the one shown at right create a Kekkai shield as protection and protect those who stay inside from injuries and intruders.

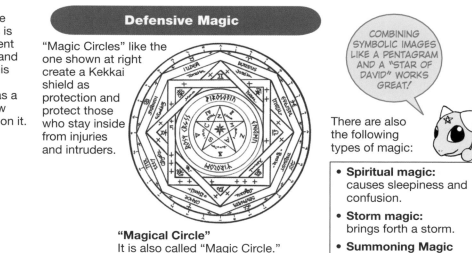

"Magical Circle"
It is also called "Magic Circle."

COMBINING SYMBOLIC IMAGES LIKE A PENTAGRAM AND A "STAR OF DAVID" WORKS GREAT!

There are also the following types of magic:

- **Spiritual magic:** causes sleepiness and confusion.
- **Storm magic:** brings forth a storm.
- **Summoning Magic**

2. Magic and Magic Equipment

What Magic is Used in Science Fantasy?

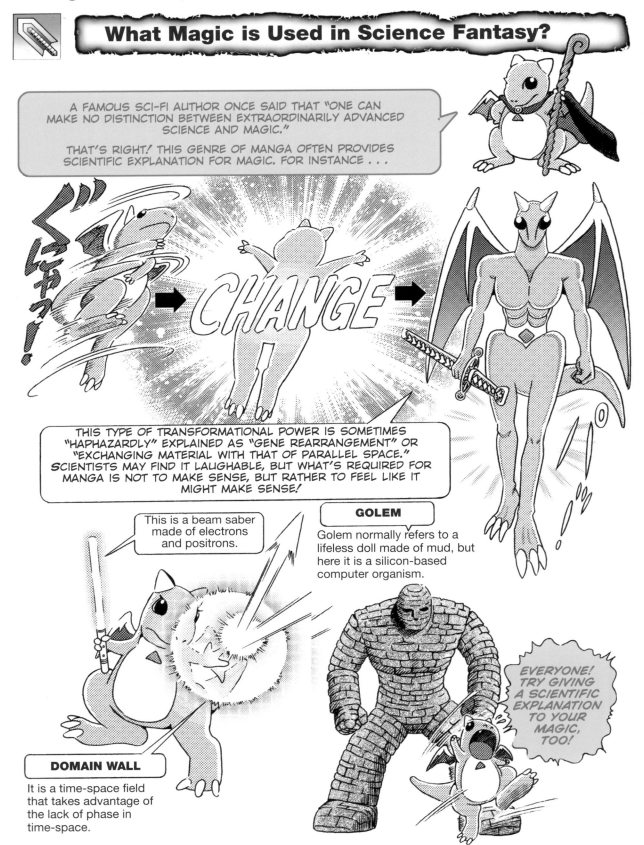

A FAMOUS SCI-FI AUTHOR ONCE SAID THAT "ONE CAN MAKE NO DISTINCTION BETWEEN EXTRAORDINARILY ADVANCED SCIENCE AND MAGIC."

THAT'S RIGHT! THIS GENRE OF MANGA OFTEN PROVIDES SCIENTIFIC EXPLANATION FOR MAGIC. FOR INSTANCE . . .

CHANGE

THIS TYPE OF TRANSFORMATIONAL POWER IS SOMETIMES "HAPHAZARDLY" EXPLAINED AS "GENE REARRANGEMENT" OR "EXCHANGING MATERIAL WITH THAT OF PARALLEL SPACE." SCIENTISTS MAY FIND IT LAUGHABLE, BUT WHAT'S REQUIRED FOR MANGA IS NOT TO MAKE SENSE, BUT RATHER TO FEEL LIKE IT MIGHT MAKE SENSE!

This is a beam saber made of electrons and positrons.

GOLEM

Golem normally refers to a lifeless doll made of mud, but here it is a silicon-based computer organism.

EVERYONE! TRY GIVING A SCIENTIFIC EXPLANATION TO YOUR MAGIC, TOO!

DOMAIN WALL

It is a time-space field that takes advantage of the lack of phase in time-space.

2. Magic and Magic Equipment

Magic in Asian Fantasy

GOGYOSETSU

According to *Gogyosetsu,* all things consist of five elements (wood, fire, earth, gold and water) and by rotating their mutual relationship, the world remains in balance. It is a concept which looks something like this in a simplified table:

Element	Direction	Color	Spirit
Wood (moku)	East	Blue	Dragon (ryu)
Fire (ka)	South	Red	Phoenix (hoh-oh)h
Earth (do)	Center	Yellow	Giraffe (kirin)
Gold (gon)	West	White	Tiger (tora)
Water (sui)	North	Black	Turtle (kame)

Gogyosetsu is a philosophy, and therefore is hard to incorporate into manga as-is. Usually, spirits (like the dragon and turtle) are visualized along with their applicable directions and colors, then a simple explanation (like "this represents *Gogyosetsu*") is given.

This is the Holy beast, Giraffe, that represents center and yellow.

FUJUTSU

A sample Fu.

Fujutsu is a sorcery originated from China. It works by writing a spell onto a piece of paper called a Fu (Ofuda). A Fu is used directly or wishes are loaded onto it. In the East, the prevalent thought is that letters themselves have magical powers. That's why different letters are used for different purposes.*

In manga, Fu are often used to get rid of monsters or for sealing things (like evil spirits and another self) that must not be let out.

*There can be copyright issue with existing letters. So make sure to change them before using them.

KOTODAMA
(mysterious power of words)

Just like Fu's line of thinking, Kotodama assumes that words themselves have magical powers.

臨 者 烈
兵 皆 在
闘 陳 前

Classic expression!

THERE WAS A MOVIE LIKE THIS . . . RIGHT?

This is the so-called "Kuji (Nine Letters)" — the old Japanese magical words. Miracles are performed by chanting these words while drawing figures in midair with hands or holding one's hands together in a specific way.

Let's Draw Western Medieval-Style Magic!!

LET'S PRACTICE HOW TO HANDLE A SCENE WHERE MAGIC IS USED, AND THE USE OF SPECIAL EFFECTS!

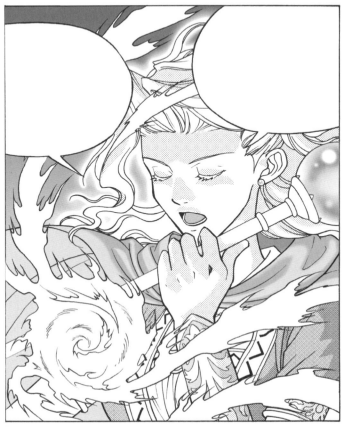

This is a scene where a magic-user chants a spell and tries to create a blazing ball. Pay attention to the way flame is drawn, as well as how shadows are applied to the character upon whom the flame shines.

Drawing Steps

❶ DRAW A ROUGH CONCEPT SKETCH.

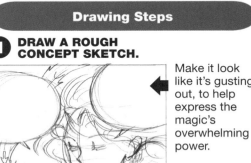

Make it look like it's gusting out, to help express the magic's overwhelming power.

Something is gathering in midair and forming a flame. The flame is small, compressed, and swirling. The arrow drawn in the rough sketch shows the flow of the flame. A typhoon is used for a motif.

❷ DRAW A DRAFT.

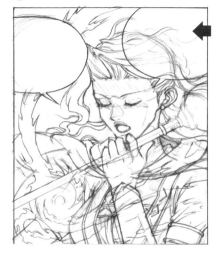

Put aside large bubbles for dialog. If the draft is inked with pen at this stage, it'll be easier later on.

❸ INK THE DRAFT WITH PEN.

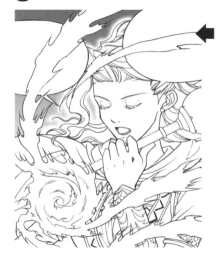

The effect surrounding the character is "blur" done in tone, which makes it look as if soft light is radiating around the character.

How to Draw Flame

There is no particular rule, but here is one example!

Sample: **Bonfire**

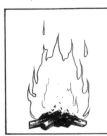

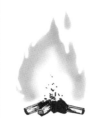

Line method Tone method

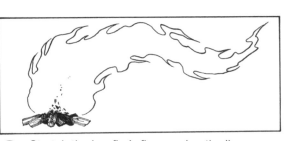

1 Stretch the bonfire's flame using the line method.

2 Apply the same method. The illustration on the left page has the flame flowing like this . . .

3 As you draw the flame, keep its flow in-mind.

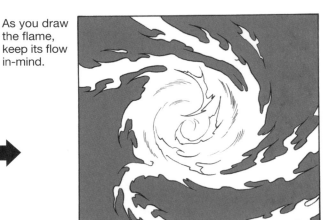

How to Add Shadows

Let's Pay Special Attention to Lighting . . .

Depending on how shadows are applied . . .

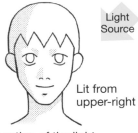

Light Source — Lit from upper-left

Light Source — Lit from upper-right

. . . the location of the light source is indicated. Shadows also help the face look three-dimensional. By the way, this is only one example of how to compose the shadows!

Lit from behind

Illustration from the left page. It's easy to tell that the light originates from under her face.

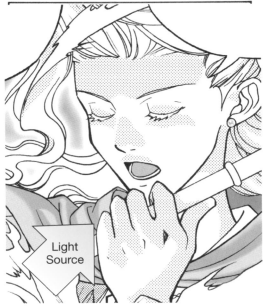

Light Source

Let's Draw Attack Magic!

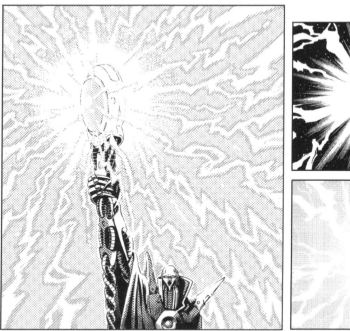

ALTHOUGH MAGIC SHOULD BE A PEACEABLE TOOL, MANGA IS NOTHING BUT ENTERTAINMENT. WE NEED TO DRAW SOME COOL FIGHTING SCENES!

Draw the "lightning" by hand at the center of the image.

This is what it looks like after a commercially available screen tone is applied.

This depiction, with electric arcs, is very common. The image on the above-left is a finished image after the screen tone is double-layered. Here is how it's done:

1 First apply a net tone, and shave where electric discharge occurs.

2 Apply the same net tone on top of it. Pay special attention to the angle to avoid a moiré effect.

3 Keep the electric area and cut off (or shave off) the rest.

4 Paint white poster color over the bolts.

IF IT'S HARD TO PAINT WHITE, USE AN ERASER TO REMOVE OILINESS FROM THE SURFACE OF THE TONE. BUT BE CAREFUL NOT TO APPLY THE ERASER TOO HARD, BECAUSE THE TONE PRINT WILL TURN FAINT!

Let's Draw Asian Fantasy Magic!

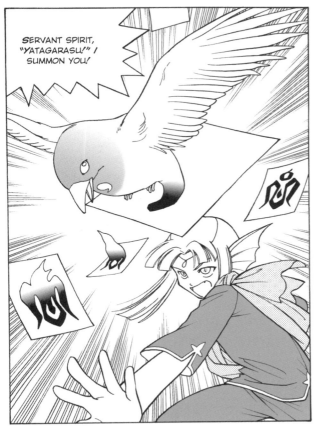

SERVANT SPIRIT, "YATAGARASU!" I SUMMON YOU!

A character flings a marked Fu, and summons servant spirits. The mark is an original design.

FOR MANGA, IT IS CRITICAL THAT THE VISUALS BE UNDERSTAND-ABLE. THE IMAGE MUST ACCURATELY COMMUNICATE TO THE READERS WHAT'S HAPPENING!

Dialogue helps the readers understand the scene, too.

Designing the Mark

Yatagarasu is a big bird that appears in Kojiki (an oldest book of history on ancient Japan). Using it as a motif, create a servant spirit and a mark.

A big bird of blue and white

Turn the image of a bird spreading its wings into a hieroglyphic sign mark.

Alter it to a Sanskrit-style letter.

How to Draw the Fujutsu Effect

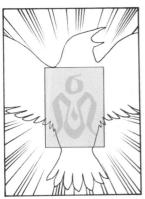

Overlap
Overlap the image of the bird to the Fu and make it look like the bird is appearing in midair.

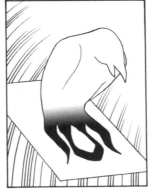

Transform
The mark on the Fu itself transforms into a bird.

This shows the Fu flashing light.

Transformation process

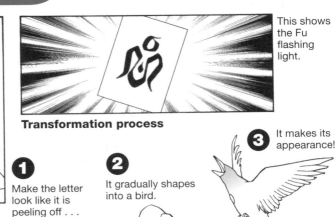

1 Make the letter look like it is peeling off . . .

2 It gradually shapes into a bird.

3 It makes its appearance!

Let's Digitally Illustrate a Magic Scene!

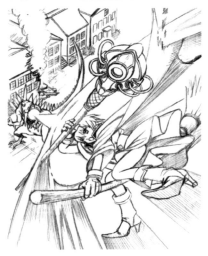

IT'S HARD TO DRAW SPECIAL EFFECTS FOR MAGIC AND SUPERNATURAL POWERS. BUT COMPUTERS MAKE IT SURPRISINGLY EASY.

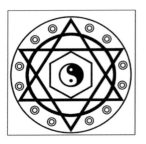

1 Draw a rough draft. This is an image of an apprentice witch, who courageously challenges a monster attacking a town.

2 Trace the rough draft, render two line drawings (one for the character and another for the magic circle), scan them into *Photoshop 6.0* with printing resolution set at 350dpi, and layer them.

3 Create a new layer and color the base.

4 Add in the shadows.

5 Using the gradation tool, roughly paint the background.

Point !

If you use the brush tool for coloring and you make the borders between base colors and shadows distinct, the image will look more like an animé cell drawing.

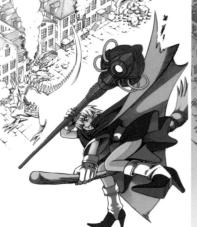

6 Paint the monster's base in green.

UP!!

7 By using the "Filter"— "Artistic"— "Sponge effect", generate the dinosaur's skin.

8 Change the line drawing color for the magic circle to blue. Make a copy of the layer and stack the two together with a slight shift. Lower the opacity of each layer and make them semitransparent.

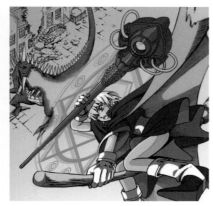

9 By doing "Edit"— "Transform"— "Distort," adjust the angle and make the magic circle align with the character's orientation.

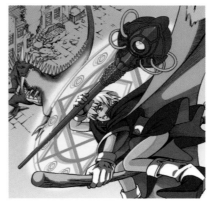

10 Make the magic circle layer shine by "Layer"— "Layer Style"— "Outer Glow"— "Screen Mode."

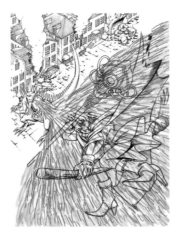

11 Except for the line drawing, make the layers invisible and draw lines for the flame with brush.

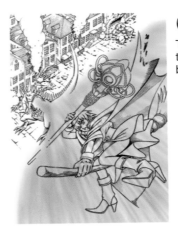

12 Try "Filter"— "Blur" a few times and make them blur.

There is a finished color illustration on page 122.

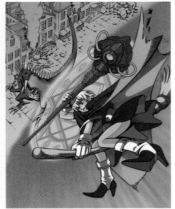

13 Add depth to the color by copying the flame layer, turning the color into deep orange by "Image"— "Adjust"— "Hue/Saturation" and stacking it in layer mode (on Multiply).

14 Using the brush tool, draw the flame bursting out of the dragon's mouth.

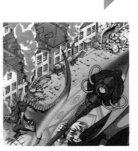

15 Add shades by applying colors to shadows and smoke from the buildings.

Let's Draw Fantasy Manga!

CHAPTER 5

At last, it's time to practice making manga! If you've got the basics down, you'll be fine. What's important is not to give up halfway!

Let's Draw Fantasy Manga!

So far we've worked on characters, their worlds, and the items they use. In this chapter, we will work on creating a story and actually drawing manga. Although each artist has his or her own method, we'll follow a general procedure.

STEP 1. Coming Up with Ideas

If you decide to draw a manga, you're likely to end up spending most of your time looking at a plain, white piece of paper. It's important to make a habit of writing down ideas when they come to you. It might help you to form a story and images you want to draw. Ideas should be waiting for you everywhere in your daily routine!

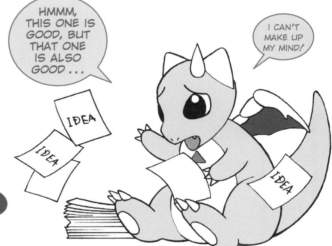

> HMMM, THIS ONE IS GOOD, BUT THAT ONE IS ALSO GOOD . . .

> I CAN'T MAKE UP MY MIND!

IDEA

IDEA

IDEA

* For example, the objective of the original manga created for this book and included in page 130 is "to defeat evil as a team."

Think About the Main Characters' Objective(s)

It's important to establish a goal that can be understood easily by the readers. If it's hard to follow what the characters are doing, readers will be confused.

For example, one objective could be saving the world— or returning to the land where the character is originally from, or "destroying evil."

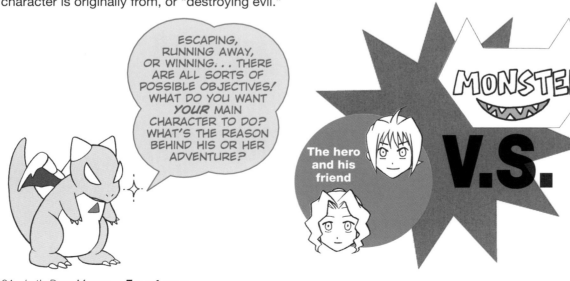

> ESCAPING, RUNNING AWAY, OR WINNING. . . THERE ARE ALL SORTS OF POSSIBLE OBJECTIVES! WHAT DO YOU WANT *YOUR* MAIN CHARACTER TO DO? WHAT'S THE REASON BEHIND HIS OR HER ADVENTURE?

The hero and his friend

MONSTER

V.S.

STEP 2. Establishing the Plot

Once you have an objective for your characters, block out a story. You don't need to write up a detailed, novel-like narrative. All you need is a simple story outline and an itemized list of characters. This is what we call Establishing the Plot.

Apparently, there are some veteran artists who start drawing directly on manuscript paper without storyboarding (which is described in STEP 3, and some say it's because they can't get themselves to start working until the deadline is right around the corner). For beginners, it's best to establish a process.

① EARLY-STAGE PLOT

Characters:	Western medieval fantasy style Eric, Theodora, King, Dwarf, Brownie
Stage:	A ruin they come across during their journey
Pages:	5
Objective:	Getting rid of monsters

GRRRR
3 MONSTERS
MONSTERS
ATTACK.
SPELL, THEODORA WIND TO SURROUND
THE WALL OF WIND TO SURROUND
THEM.
REPELLED BY THE WALL, MONSTERS
ARE THROWN OFF. KING KILLS ANOTHER.
DWARF KILLS ONE. KING KILLS ANOTHER
THE LAST ONE KIDNAPS BROWNIE AND TRIES
TO RUN OFF.
 "GRR GRR GRR..." "HELP!"
ERIC
 "GEEZ!
 DIDN'T I LECTURE YOU ABOUT THIS?!"

THEO "ERIC, MAGIC SWORD!"
ERIC "I COUNT ON YOU!"
 BROWNIE STOPS MOVING FOR A MOMENT.
 ERIC STRIKES IN A FLUSH.

 END

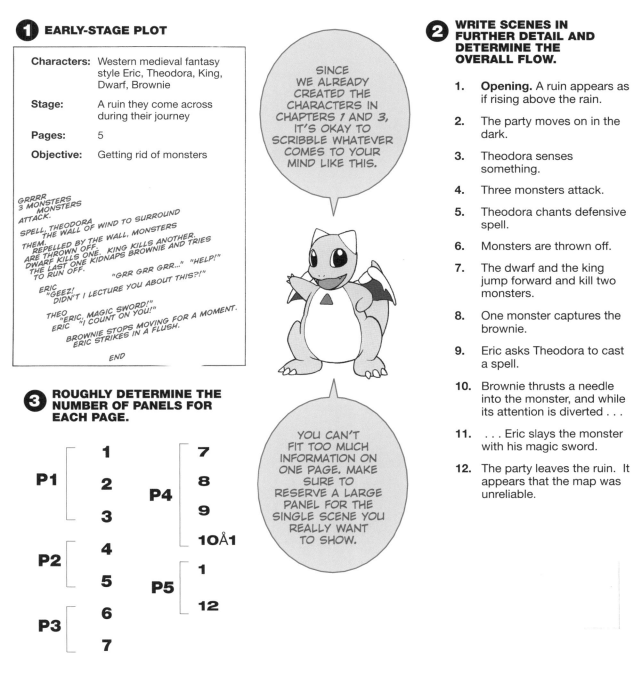

SINCE WE ALREADY CREATED THE CHARACTERS IN CHAPTERS 1 AND 3, IT'S OKAY TO SCRIBBLE WHATEVER COMES TO YOUR MIND LIKE THIS.

YOU CAN'T FIT TOO MUCH INFORMATION ON ONE PAGE. MAKE SURE TO RESERVE A LARGE PANEL FOR THE SINGLE SCENE YOU REALLY WANT TO SHOW.

② WRITE SCENES IN FURTHER DETAIL AND DETERMINE THE OVERALL FLOW.

1. **Opening.** A ruin appears as if rising above the rain.

2. The party moves on in the dark.

3. Theodora senses something.

4. Three monsters attack.

5. Theodora chants defensive spell.

6. Monsters are thrown off.

7. The dwarf and the king jump forward and kill two monsters.

8. One monster captures the brownie.

9. Eric asks Theodora to cast a spell.

10. Brownie thrusts a needle into the monster, and while its attention is diverted . . .

11. . . . Eric slays the monster with his magic sword.

12. The party leaves the ruin. It appears that the map was unreliable.

③ ROUGHLY DETERMINE THE NUMBER OF PANELS FOR EACH PAGE.

P1 — 1, 2, 3

P2 — 4, 5

P3 — 6, 7

P4 — 7, 8, 9, 10Å1

P5 — 1, 12

STEP 3. Storyboarding

Once you've got the plot down, put together a storyboard. You can use any paper— be it storyboard paper, a notebook or the back of a flier.

Create the rough framework of the manga by including images of characters (in minimum detail that at least communicates who and what), dialog, sound effects, and visual effects.

Basic Structure and How to Read

START

This is the starting point with Japanese manga magazines,

In Japan, the starting point is usually the upper-right corner of the right page of two-page spread. The flow of the panel starts from the upper right and ends at the bottom left. Japanese dialogue is written vertically and lines are written from right-to-left. In this book, however, the panels start on the upper left and end at the bottom right.

Flow of the Panels and Basic Layers

For commercially-sold manga, 3 to 4 layers of panels per page are considered appropriate. If it has more layers, it becomes harder to read.

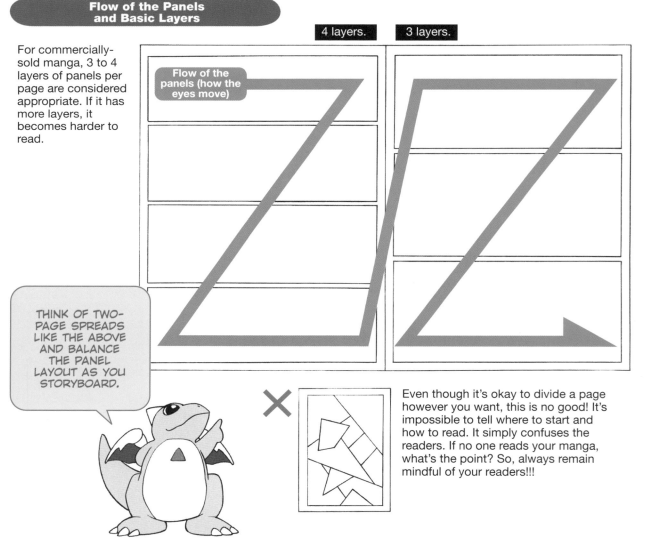

4 layers. 3 layers.

Flow of the panels (how the eyes move)

THINK OF TWO-PAGE SPREADS LIKE THE ABOVE AND BALANCE THE PANEL LAYOUT AS YOU STORYBOARD.

Even though it's okay to divide a page however you want, this is no good! It's impossible to tell where to start and how to read. It simply confuses the readers. If no one reads your manga, what's the point? So, always remain mindful of your readers!!!

- Think in terms in two-page spreads.
- Capture the reader's interest at the start of the story.
- Always try to make the last panel of the page a cliffhanger.
- If you want a panel to give a strong impression, draw the characters facing the readers.
- Give the characters a problem to deal with.

A Storyboard Excerpt

Page 130

(1)

A RUIN ON THE OUTSKIRTS OF THE TOWN . . .

UPON LEARNING THAT IT CONTAINS AN ENTRANCE TO THE "MAGICAL SPRING," THEY GO IN . . .

DO YOU REALLY THINK THERE'S A PATH TO THE SPRING IN HERE?

SHHHH. KEEP IT DOWN! RUMOR HAS, *DEMONS* HAUNT THIS PLACE. LEASTWISE, IT'S DANGEROUS.

SOMETHING'S HERE! GUARD-UP, EVERYONE!

(2)

·UHH.·

·t...

THERE'S SOMETHING HERE ALRIGHT!

ELUKE, HOLY GODDESS OF ETHER, GRANT ME A SHIELD OF YOUR SCANT AIR.

SPELL

I SUMMON THEE, *Wall of Wind!!*

* Read the panels in the order as numbered.

Explanation

By drawing the exterior of the building in Panel 1 and the interior as background in Panel 2, the characters' location is clearly communicated.

Panel 5 fires-up anticipation for Panel 6. By intentionally drawing the monsters in shadow, a sense of fear toward the invisible opponent is created.

Panel 6 has to be an impressive picture that can satisfy expectations! Draw it as if the monsters are jumping out of the panel.

Panels 7, 8 and 9 are divided to show a sense of speed. The moves between the panels are drawn tightly.

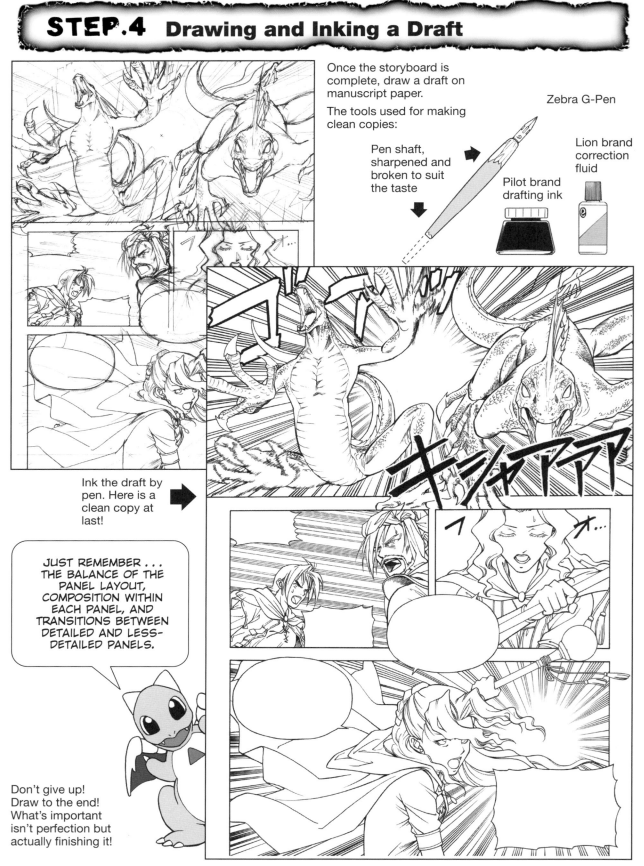

STEP.4 Drawing and Inking a Draft

Once the storyboard is complete, draw a draft on manuscript paper.

The tools used for making clean copies:

Zebra G-Pen

Pen shaft, sharpened and broken to suit the taste

Pilot brand drafting ink

Lion brand correction fluid

Ink the draft by pen. Here is a clean copy at last!

JUST REMEMBER . . . THE BALANCE OF THE PANEL LAYOUT, COMPOSITION WITHIN EACH PANEL, AND TRANSITIONS BETWEEN DETAILED AND LESS-DETAILED PANELS.

Don't give up! Draw to the end! What's important isn't perfection but actually finishing it!

The Spring Seekers

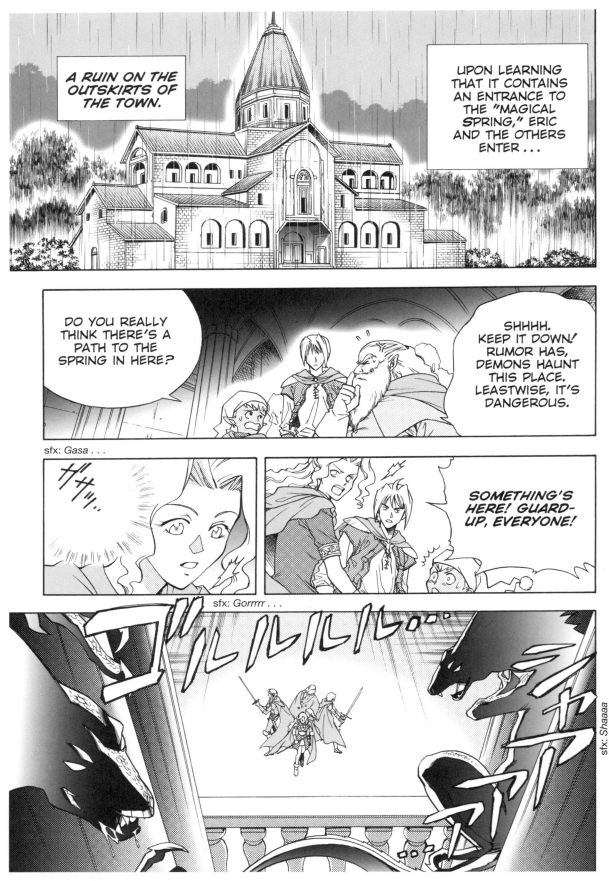

A RUIN ON THE OUTSKIRTS OF THE TOWN.

UPON LEARNING THAT IT CONTAINS AN ENTRANCE TO THE "MAGICAL SPRING," ERIC AND THE OTHERS ENTER . . .

DO YOU REALLY THINK THERE'S A PATH TO THE SPRING IN HERE?

SHHHH. KEEP IT DOWN! RUMOR HAS, DEMONS HAUNT THIS PLACE. LEASTWISE, IT'S DANGEROUS.

sfx: Gasa . . .

SOMETHING'S HERE! GUARD-UP, EVERYONE!

sfx: Gorrrrr . . .

sfx: Shaaaa

sfx: *Goah!*

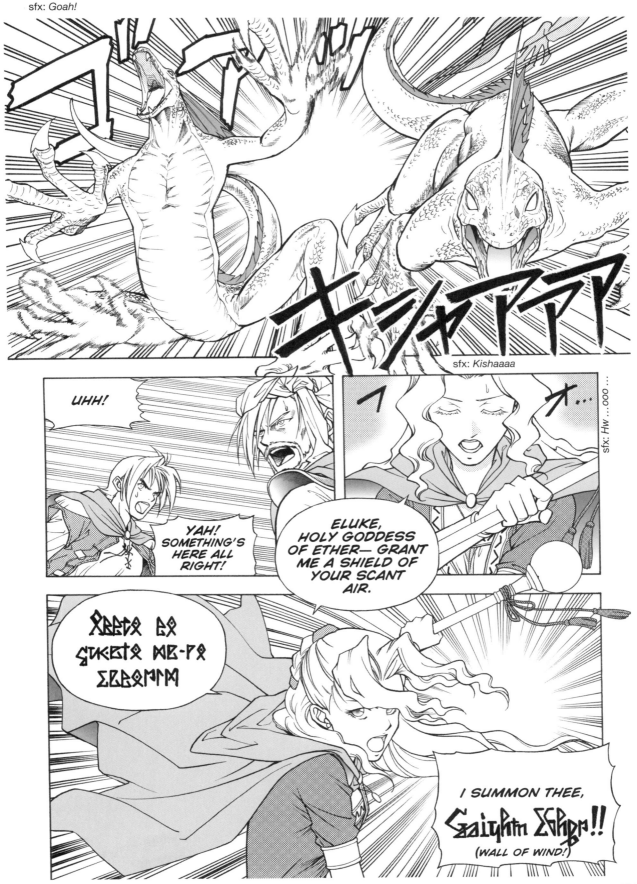

sfx: *Kishaaaa*

sfx: *Hw....ooo....*

UHH!

YAH! SOMETHING'S HERE ALL RIGHT!

ELUKE, HOLY GODDESS OF ETHER— GRANT ME A SHIELD OF YOUR SCANT AIR.

I SUMMON THEE, Gaighm Egher!! (WALL OF WIND!)

131

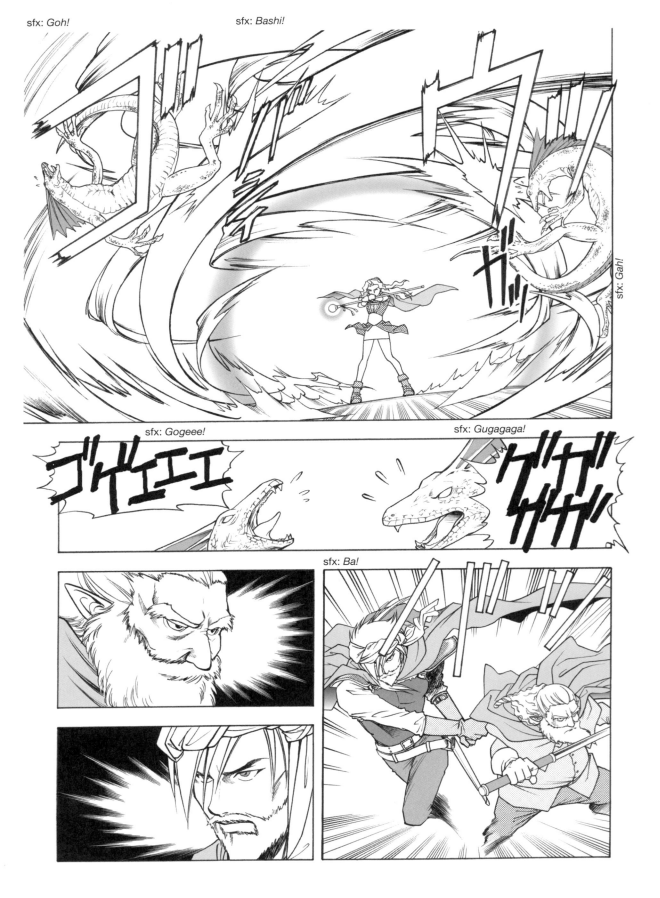

sfx: *Gah!*

sfx: *Gogeee!*

sfx: *Gugagaga!*

sfx: *Ba!*

sfx: *Zan!*

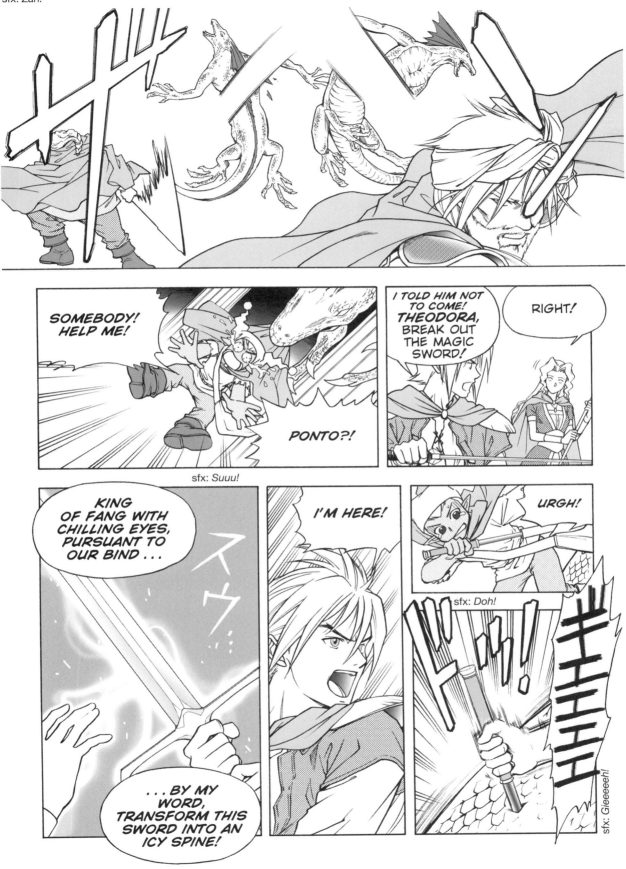

sfx: *Suuu!*

sfx: *Doh!*

sfx: *Gieeeeh!*

133

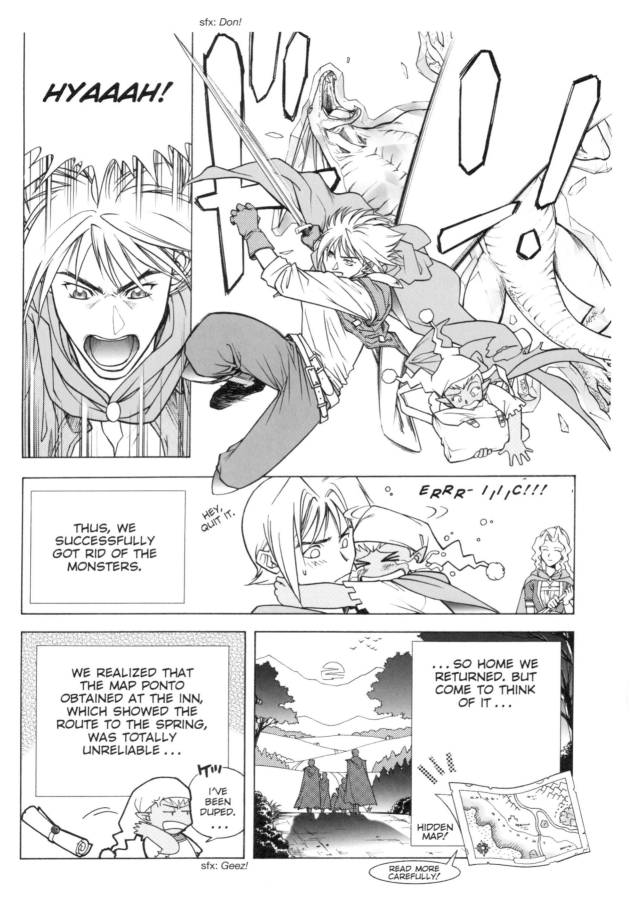

CHAPTER 6

Author Illustrations

Using Color Ink, Draw an Asian-Style Illustration by Hand!

ASTER NORIKO

She is both a manga artist and a neglectful wife. She loves mysteries and riddles. She read "The Lord of the Rings" for the first time in 1998. She is relatively new as a fan, but she has read it over and over many times. She tends to prefer mainstream fantasy. Manga she enjoys include: "FULLMETAL ALCHEMIST," "SHIN-ANGYO-ONSHI," "PILGRIM JAEGER" and "BERSERK." A novel she's looking forward to reading is "BRTIMAEUS."

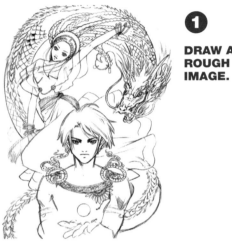

❶ DRAW A ROUGH IMAGE.

A dragon god, dance, and resolve toward the future. That's the premise of this illustration. By positioning the characters within the circular motion, the overall composition becomes harmonious.

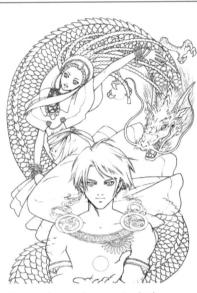

❷ INK THE DRAFT WITH PEN.

Lightly trace the rough draft using a B pencil on a piece of DELETER brand colored paper. Once it is inked by pen, remove the pencil lines with a kneaded eraser. To avoid damaging the paper, erase by pressing upon the pencil lines (rather than rubbing over them).

The ink used is Maxon Comic Ink, Sepia. It's perfect for color illustration because it becomes water-resistant after it dries.

Production environment: desk
Material used: color ink (Dr. Martin's radiant series), acrylic paint (Holbein acrylic gouache) and Canson paper 160. The drawing process for the illustration from page 7 is explained here.

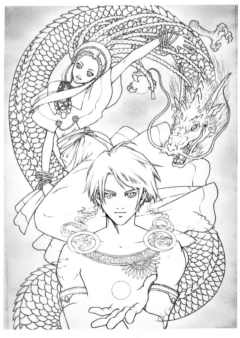

❸ DRAW A ROUGH CONCEPT SKETCH.

Mainly using beige, lightly blur the background.

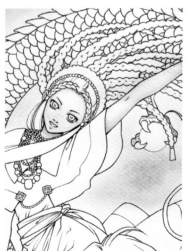

❹ COLOR THE CHARACTERS.

Start with the skin color. Use a mix of lemon yellow, ice pink and vermilion as the base, to color the skin a little at a time. Use saddle brown for the dark shadows on the girl and sepia on the boy.

5

COLOR THE GIRL'S DRESS.

Since it covers a large area, it's important to paint it first to get a good grip on the overall color tone.

6

At this point the characters are pretty much done.

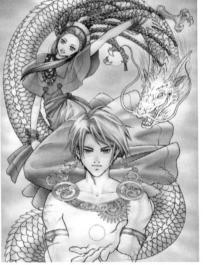

7

START COLORING THE DRAGON.

Paying attention to the overall image, lightly add the gradation.

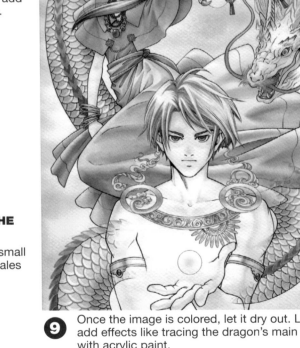

8

DRAW IN THE DETAILS.

Work on the small things like scales and jewelry.

9 Once the image is colored, let it dry out. Later, add effects like tracing the dragon's main lines with acrylic paint.

10 *See the finished image on page 7.*

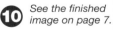

Draw Western-Style Fantasy Illustration by Hand!

BUNTA625

He's been working in this business over twenty years. Instead of beautiful things, he is more attracted to strange and alien forms, which people tend to fear and dislike. Among Japanese manga artists, he likes the worlds of Shigeru Mizuki and Go Nagai. Of American artists, he likes Mike Mignola, who did "Hellboy," although his work might not belong to the fantasy genre. He also prefers stories set in the real world rather than in a parallel universe.

Production environment: own room Material used: colored ink (Dr. Martin's)

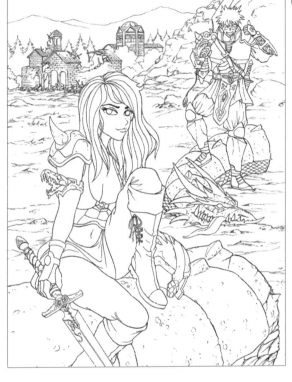

❶ FIGHTING A DRAGON IS THE PREMISE.

To avoid making the image to look too bloody, a female character is brought out up-front and the male character is drawn to look comical. First, copy the draft that's been already inked by pen onto a drawing paper.

❷ COLOR THE CHARACTERS.

Start with lighter colors like the skin. This way the image can be made darker with the overall balance in mind. Lightly color the background, too. There is no rule over whether the character or the background gets to be colored first. Start with what feels easiest to you.

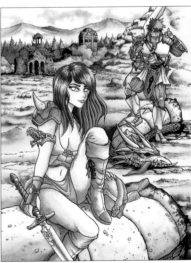

❸ ADD SHADOWS.

Make them vary by adding natural gradations.

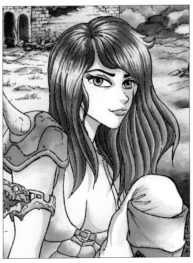

❹ CHOOSE A COLOR.

Use it as the base for the iris. Before the paint is dried, add another color in the pupil. Use white for the highlight on the iris.

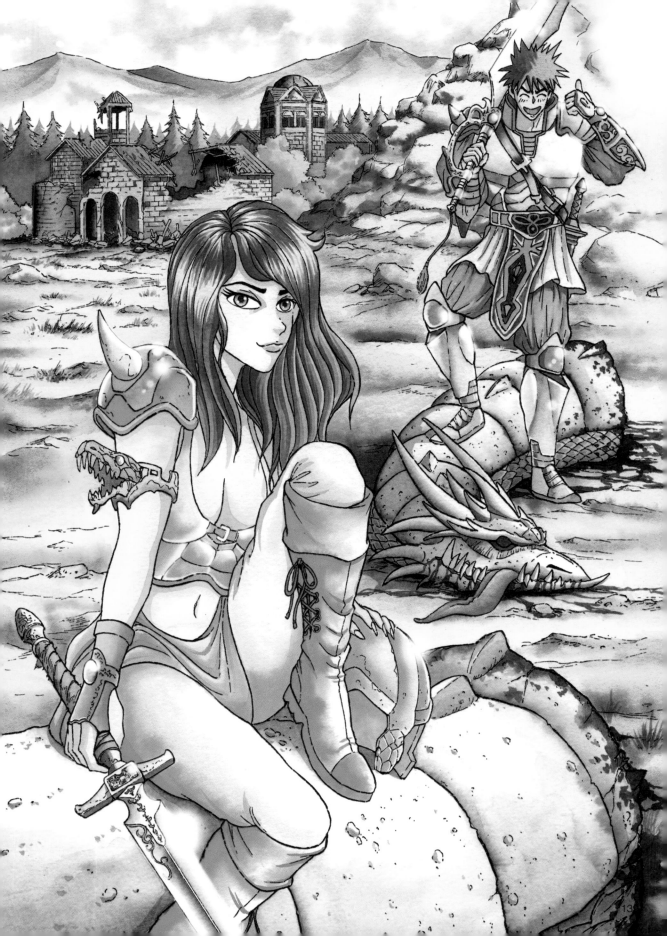

NORIKO NAKAJIMA

She is the "personal secretary," "the "assistant" and the "wife" of MAKOTO NAKAJIMA. For this book, she is mainly in charge of drawing in Photoshop.

1 (*Left*) Draw and scan images of the character, forest, and water surface. Layer the scanned images. Being mindful of the work's finished color, paint it thoroughly.

2 (*Right*) Create a new layer and color it. Copy a part of the forest; flip and paste it into the empty space on the deep left, to remove the gap.

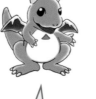

USING THE SAMPLE SPECIMENS AS EXAMPLES, ESTABLISH *12* STEPS.

3

Water surface drawing process

(To make it look easier to understand, the character is not colored in the picture below.)

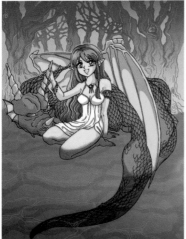

3 A Paint turquoise blue in layer mode (normal) under the water surface layer, which is already painted with base color.

3 B Under layer A, paint purple in layer mode (Multiply). Gradient tool is used for both layers A and B.

3 C Select the line drawing of the water surface, then "Select"— "Modify"— "Expand (20 pixels)," and paint it light water blue. Change the mode to layer mode (linear color), and pile it on.

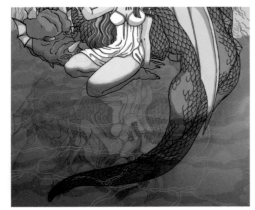

4 Merge the character layers only and make a copy. "Edit"– "Transform"— "Rotate 180," then lower the opacity of the layer and create the reflection. Then, warp the image with "Filter"— "Distort"— "Wave," giving it a wavy feel.

5 Draw the roots of the trees beneath the surface of the water and add ripples around the character. Use "Layer"— "Layer Style"— "Outer Glow" in "Screen Mode (white)" and make it light up.

The finished image is on the next page.

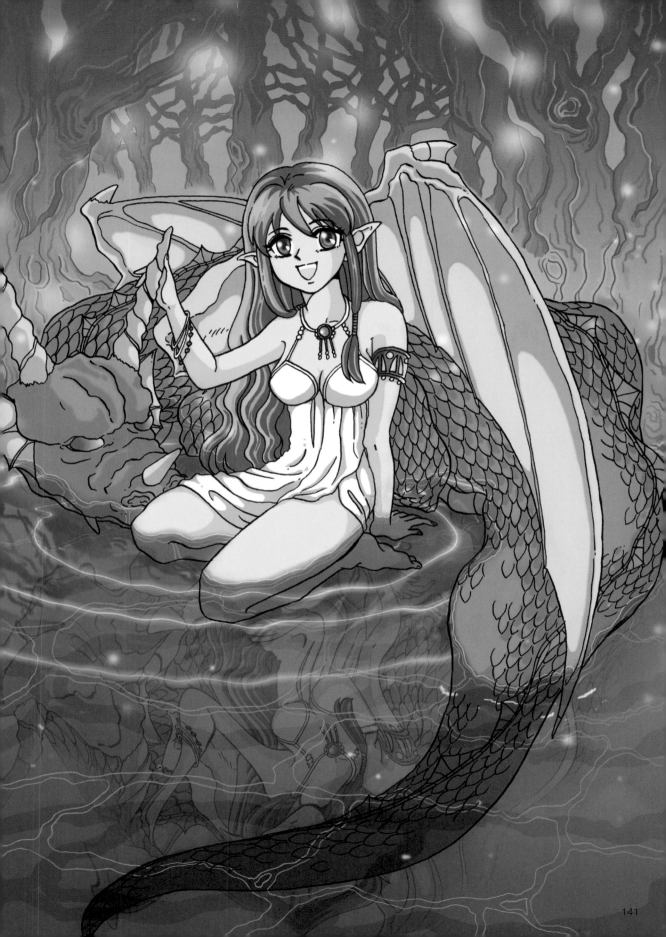

Draw a Fairytale-Style Illustration Using Painter!

MAKOTO NAKAJIMA

He is the head of Big Mouth Factory. His latest work is "SCIROCCO'S OVERMAN." The latest fantasy movie he enjoyed is "Big Fish." The latest fantasy novel he enjoyed very much is "INVOLUTION OCEAN" by Bruce Sterling. His favorite fantasy manga artist is Moto Hagio.

PAINTER NOT ONLY HAS A WATERCOLOR AND AN OIL BRUSH, BUT ALSO OTHER BRUSHES LIKE PASTELS AND COLORED PENCILS. THAT'S WHY IT'S THE PERFECT TOOL TO DRAW A FAIRYTALE-STYLE ILLUSTRATION.

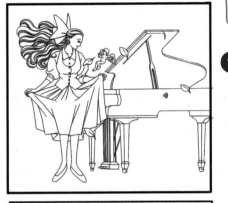

1 Scan the line drawing into Photoshop. Clean it up and layer it.

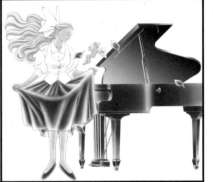

2 Under the line drawing mode "Multiply" in Photoshop, color the character. Keep in mind that the goal is to finish the image in fairytale style, so make sure not to color it too dark. Use the Gradient tool for the piano and finish it light and pale like the character. Then save the image.

3 Open Painter and draw the background. Select "Hardboard." Use chalk for the sky and the waterpaint brush for both the woods and the grassy field. Paint them roughly as the base.

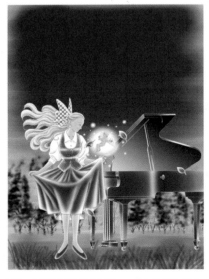

4 Merge the character and the background in Photoshop. In Painter, color the girl's vest jacket in pastel. For her ribbon, use "polka dots" from the nozzle selector.

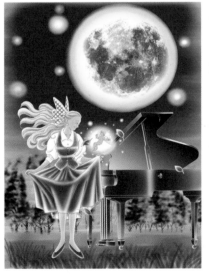

5 Go back to Photoshop again. Add the image of the moon and make it light up with a brush.

6 The finished image is on the next page. As a finishing touch, the image of the musical notes is added, and using the "Image Horse" of Painter, the picture frame with leaves is added.

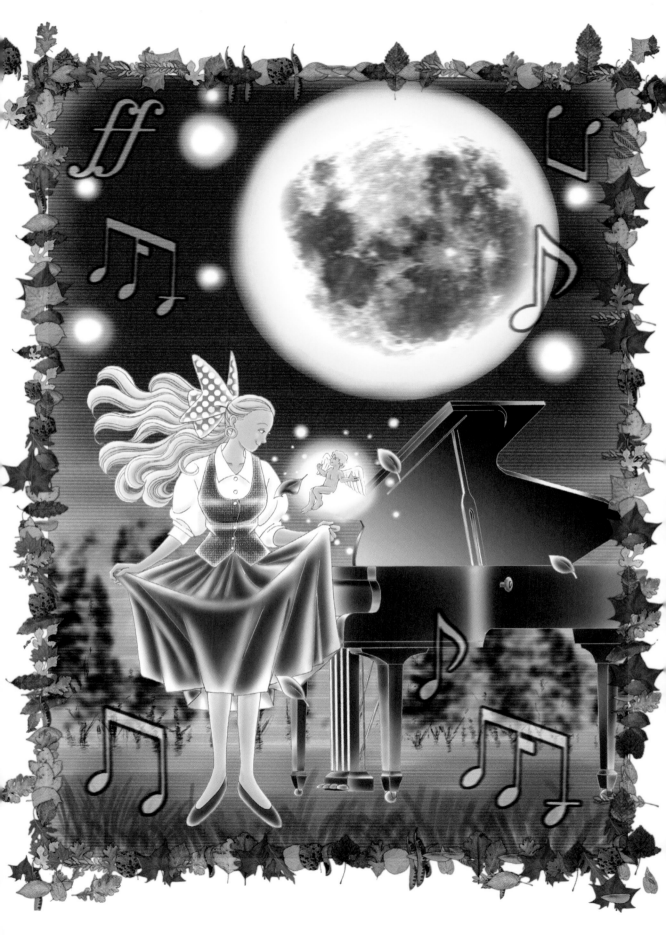

Postscript

Until the early 1980s, the Japanese manga industry had this belief that fantasy manga could not be successful. What swept away this notion were the so-called "role-playing games"— the fantasy-style videogames made for home entertainment. They brought social phenomena like all-nighters (in places like Akihabara) on release dates. The generation that grew up with these games readily accepted fantasy manga, and they support this genre's current prosperity. Also these manga, more often than not, base their stories on Western legends and folklore, and therefore, fortunately, have an "international" feel to them. I believe most of the Japanese manga you see today belong to this genre. Aster Noriko, who is the main author of this book, also belongs to the generation who readily accepted fantasy through games and manga. You can see her love of fantasy everywhere in this book. As one of the authors, I'll be more than happy if you can feel it too.

This book is structured around three worlds with different styles: The world that succeeds the traditional, Western-style fantasy and the fantasy world based on Eastern folklore and legends. (The original Japanese script omits the third world – presumably Science Fantasy.) To make the best of our abilities, Aster Noriko was in charge of the first two worlds while I, Nakajima, was in charge of the third world. There is a reason why we categorized fantasy into three different worlds.

Since ancient times, there has been an animism-like philosophy in Japan – that "everything in nature has a soul" kind of idea – and

historically, Japan has been very tolerant of foreign cultures and religions. Or rather, Japan has been more aggressive in absorbing them. For those who grew up in a culture supported by one clear-cut religion, it may be difficult to understand this, but in a way, the value of every culture and religion is the same in Japan. Thus, the fantasy worlds expressed in subcultures like manga, games, and novels written for entertainment hardly ever have a unified and cohesive cultural and religious background. Instead, they are exceptionally complex and disorderly. (The "lack of nationality" often seen in Japanese manga and animé is, in a way, largely due to this historical and cultural background.) Such a Japanese fantasy-manga-world is impossible to cover in a single book. That's why we decided to tackle it by dividing it into three major representative styles. In reality, these three styles are often mixed up and commingled together in a single manga. I hope you will enjoy this book with an understanding that this is the reality of the market.

By the way, starting with this book, Big Mouth Factory's "Let's Draw" series will have colored pages, too. I hear "color cell-drawing illustration" influenced by Japanese animé is popular in the U.S.A. But in contrast, "hand drawing style illustration" (even if it is digitally done) is more popular in Japan. In this book, we tried to include both styles. I hope you will be pleased with our effort.

Last but not least, I would like to express our heartfelt gratitude to D.M.P. and Mr. Ken Sasahara, the producer, who agreed to participate as early as the planning stage and listened to our numerous and unreasonable requests.
Thank you very much.

Big Mouth Factory
(Makoto Nakajima)